01/22

W9-CSN-967

WOMEN

⟫⟫ of ⟪⟪

Martha's Vineyard

THOMAS DRESSER

Foreword by Rose Styron

Charleston London

THE
History
PRESS

Published by The History Press
Charleston, SC 29403
www.historypress.net

Copyright © 2013 by Thomas Dresser
All rights reserved

Front cover, top left: Dorothy West. *Courtesy of Alison Shaw. Top right*: The Adams sisters. *Courtesy of the Martha's Vineyard Museum. Middle*: Emily Post. *Courtesy of the Emily Post Institute. Bottom left*: Doris Jackson. *Courtesy of her daughter, Lee Van Allen. Bottom middle*: Polly Hill. *Courtesy of Alison Shaw. Bottom right*: Dionis Riggs. *Courtesy of her daughter, Cynthia Riggs.*

Back cover: Dionis Riggs. *Courtesy of her daughter, Cynthia Riggs.*

First published 2013

Manufactured in the United States

ISBN 978.1.60949.903.7

Library of Congress CIP data applied for.

Notice: The information in this book is true and complete to the best of our knowledge. It is offered without guarantee on the part of the author or The History Press. The author and The History Press disclaim all liability in connection with the use of this book.

All rights reserved. No part of this book may be reproduced or transmitted in any form whatsoever without prior written permission from the publisher except in the case of brief quotations embodied in critical articles and reviews.

To the memory of my mother, Louise Thomas Bender Dresser.

I recall grasping the concept of writing at my mother's knee.

My mother preferred writing letters to talking on the telephone. As a youngster, I used to watch her continuous script as she wrote, and I tried to imitate her scroll, but all that came out was a series of looping e's. That's when she explained the power of writing.

One dreadfully long summer when I was in junior high, she dragged me, my brother and a friend inside each morning to teach us how to type. I thought it was excruciating to sacrifice those few precious hours of summer, inside, struggling over a complicated keyboard. But of course, those hours of torture evolved into a lifetime of learning and writing.

My mother always wrote but never had a novel published. She never won an election or made the front page, but she did encourage, urge and inspire us. She was always there for the family, on the back pages, offering support, advice and encouragement.

She died thirty-five years ago. Her legacy lives on.

For that, and much more, I dedicate this book to her.

02/21

$3.50

Contents

Foreword

I asked poet and human rights activist Rose Styron for a few words as a foreword to this book. "I've never done an introduction this way before," she demurred as we met in her sunny living room on a cold, wintry day. Her schedule was tight. "I'm in the middle of my book tour. Bunch of Grapes was the first stop. It was fun." In many cities across the country, Rose was promoting her new book: *Selected Letters of William Styron.*

I wanted to talk about her view of the Vineyard, the import and contributions of women.

Rose shared memories of her first Vineyard visit:

> *My first glimpse of the Vineyard was in the late '50s, when Bill and I and our small daughter, Susanna, took the ferry from Nantucket, stopping on the way back home to Roxbury, Connecticut. We'd been invited by Hiram Haydn, Bill's editor, who had a place here. Arriving at the steamship dock, we didn't see Hiram, but we did spot Lillian Hellman, whom we'd met serendipitously in Rome at our wedding. She stopped shouting at her huge poodle ("Gregory Zilboorg! Come back here!") and spotted us. Chortling, and welcoming, she invited us to her harbor house, promising we could phone the Haydns from there. Dashiell Hammett was sitting on the porch. Susanna climbed into his lap. They seemed mutually enchanted. By the time we'd left, having gazed at*

the lovely boating scene and heard about the wonders of the Vineyard (as opposed to "That Nantucket"), Lillian had convinced us to rent a neighboring house for a few weeks the following summer. By then, our second daughter, Polly, was a few months old.

Bill and I and our growing family soon became summer people. Anticipating the birth of a third child sometime in September 1959, we rented the big yellow clapboard Victorian house owned by Theo Jay, between Lillian's house and the Vineyard Haven Yacht Club, for the first weeks of August.

Our pals Lewis Allen (he and Mike Nichols produced the original Annie) and his wife, Jay Presson (she adapted The Prime of Miss Jean Brodie *for Broadway), came to visit. Lewie and Bill took a boat off-island. Jay and I bundled our three little girls into the Jeep and drove to Gay Head to watch the sunrise over the high, more pristine, brightly colored clay cliffs. Standing at the top, alone, we heard an anguished cry from far below. Jay said, "I can see a woman who seems to be stuck or lost in the gorse. You wait here; I'll scramble down and lead her out." Bye, Jay. Five minutes later, my water broke, and I went into labor. Further adventures are another funny story (what could we do but laugh?). We have a native son, Thomas Styron, born in the tiny Martha's Vineyard hospital between a five-year-old having his stomach pumped out (he'd swallowed a jar of brown paint, assuming it was chocolate milk) and an elderly gent who'd fallen off a ladder, his broken leg in the process of being set.*

"Hope you didn't want anesthesia," the delivery nurse greeted me. "The guy who gives it is in Falmouth. No time. And Dr. Nevin isn't here yet…"

Soon, Bill and Lew and Jay and the little girls, and Lillian with a big basket of lobster and champagne, were peering in at me from an outside window.

Rose stopped and then said, "But this book is not about me. It's about a series of strong women in Vineyard history—nurses, writers, visual artists, political candidates, dedicated community leaders—and their history. Should I go on, Tom?"

"Yes, of course," I replied.

Pretty much a summer and holiday resident for years, I was pleased to become friends with other women on similar schedules, many quite exceptional: Kay Graham, Jackie Kennedy, Virginia Durr, then— close now for forty years—tennis and beach buddies Lucy Hackney

and Tess Bramhall, who've led our island's community services and environmental endeavors (e.g. Mental Health Initiative and Conservation Partnership), plus Charlayne Hunter-Gault, star journalist and civil rights activist who welcomes Vineyarders of every age, stripe and persuasion to her home and who are also year-round citizens now and, also, Carly Simon, terrific Carly who lends her presence and talent to our annual auction and other public and private events. And Pulitzer Prize–winning Geraldine Brooks, who chronicles Wampanoag history in fiction; and Mary Wallace, Diane Sawyer, Connie Ellis, Cathy Ashmun and Kate Taylor, among others, who are ready with island support of every kind; and, of course, Jorie Graham and Fanny Howe, who lift our spirits through poetry. We hope Hillary Clinton will return soon, and often, and resume our beach walks. I'm proud to count as friends, too, I believe, many other women, most much younger, who give time to encourage current island projects in a big way, from the schools and playing fields to housing and health and the theater.

I wish I'd got to know Dorothy West. She invited me into her cozy Oak Bluffs house one Illumination Night. I wish I'd met Emily Post. I didn't know she lived in Edgartown. My mother and then our youngest daughter, Alexandra, were her fans—Al's adopting Emily Post's "rules" helped produce a glorious wedding on Caroline Kennedy's hillside. Caroline, as we all know, is a very accomplished woman—her poetry anthologies are by my bed, her speeches in my head. I've known her since she was a little girl. She and her mother and brother, John John, came to stay with us for a few days the summer after her father's death.

In 1961, Bill and Rose Styron began coming to the Vineyard for longer and longer annual stays.

A particular memory involves the purchase of their house on Vineyard Sound. The Styrons joined the Yacht Club, adjacent to the big lawn fronting the home of Mr. and Mrs. Samuel Eels. At season's end, having rented variously in Katama, and off Hatch Road and near the Eels property, Rose inquired at a real estate office about rentals available the next summer. As it happened, that very moment, Agnes Eels called the realtor to say her husband had passed away and she wanted to sell as soon as possible and return to Ohio. Rose, having no prior thought of buying, heard herself say that the Styrons would like to have it. Clearly, she had not consulted her husband. The realtor told Rose if she could get the money instantly, she could own the house. Rose immediately got on the phone and persuaded

Bill, who helped work miracles, to borrow and transfer dollars to their account, and somehow it was arranged and a check promised by bedtime.

Rose picks up the tale:

> *I called Mrs. Eels and asked if I could bring it in the morning and she said, "Yes! I'm happy because I want children to live here and love it as we have. We met your daughter when she fell off the bike she was trying to ride across our seawall…"*

But about 8:00 a.m., the realtor called Rose to say he was sorry, she didn't get the house after all; another client had bid twice as much, and as the Eels' agent, he had to accept.

Rose explained:

> *I called Mrs. Eels to repeat my condolences and say I was disappointed (I was actually crushed), but certainly understood, and said that Bill and I sent her every good wish for the future. Her sister Marion answered the phone: "Of course you got the house. We accepted your offer last night. And Agnes has gone out to get her hair done to be ready for you. Hurry."*

It was all woman-to-woman. Agnes returned, Rose handed her the check and they celebrated by the fireplace. "I'll never forget their generosity," says Rose.

Rose reflects on the bounty of her life:

> *I lucked out being Bill's wife, helping secure his privacy for writing and still able to be a mom and write and be involved in human rights and go off on birding trips or travel afar with Bill and our pals, most of them literary. About the Vineyard: this island foments friendship. Obviously, I feel incredibly fortunate to have a corps of good friends, so many of them women, all of whom I met here. I'm particularly gratified that a number of our children and grandchildren who spent happy times here growing up are still in close touch and carry on family traditions—football on our lawn and much more—together.*

She adds:

> *Among our best memories are the collaborative sunset/moonrise beach picnics at Squibnocket or Black Point or Seven Gates. I long for such to*

continue. Sunset and sunrise on the Vineyard are so very special. I look forward to the sun's progress—left to right—across the theater beyond our bedroom window as the seasons transit spring to winter, each morning now. Once the beautiful snow is gone, and the eider ducks no longer swim beyond our dock, the mallards will waddle up the green lawn to be fed, to keep me company as I write on the front porch.

<div align="right">

Rose Styron
Vineyard Haven
February 2013

</div>

Rose celebrates the Vineyard in her poetry:

Beach Walk[1]

I'm older than these spiky cliffs
and older than the sea,
walking the silent sunrise beach
there's no one old as me.

No one to think of deaths to come
nor watch our footsteps fading
fast in the sands of morningtide
where wind and I go wading.

Acknowledgements

This is my fifth book with The History Press, and once more I want to thank my editors, publishers and publicists for their excellent work on creating this volume. Thank you Jeff Saraceno and Dani McGrath, especially, for encouraging me on this venture. And thank you Jaime Muehl for editing the manuscript. Vineyard history comes alive with your efforts.

Again, I was dependent on the archives of the *Vineyard Gazette* for useful facts and stories, dating back to the nineteenth century. Obituaries, especially by Julia Wells, offered a wealth of information as well. Once again, too, the files of the Martha's Vineyard Museum proved a useful source of both written data and images. My thanks to Dana Street for her efforts. And two librarians stand out: Anna Marie D'Addarie of Oak Bluffs and Betty Burton of Vineyard Haven. My gratitude for your support.

Linsey Lee of the Martha's Vineyard Museum offered personal assistance, as well as the professional volumes of *Vineyard Voices* and *More Vineyard Voices*, both deep with archival history. Susan Catling of *Martha's Vineyard Magazine* provided helpful hints. Florin Gafencu of Mosher Photo was a great help in producing clear, near-perfect images.

However, it was the personal interviews that ensured such rich rewards. I enjoyed meeting and communicating with Kati Alley, Kerry Alley, Peter Benjamin, Jeff Caruthers, Patsy Costa, Sally Hamilton, Michele Hodgson, Tom Hodgson, Aase Jones, John Lamb, Mark Lovewell, June Manning, Shirley Mayhew, M.J. Munafo, Peggy Post, Joyce Rickson, Cynthia Riggs,

ACKNOWLEDGEMENTS

Alison Shaw, Karin Stanley, Rose Styron, Yvonne Sylvia, Deborah Toledo, Lee Van Allen, Loren Van Allen, Bettina Washington, Nancy Weaver, Julia Wells and Carl and Pam Widdiss. Each of you added a wealth of personality to the story; your love and admiration were unquestioned. By providing access to your personal trove of memories, you generously burnished the stories that lie ahead.

And to Joyce. When we first met, back in junior high school, who knew you would be my partner, editor, photographer and wife? Thank you for editing this book, in detail, with care and comment. Your words carry great weight with me.

My thanks to all are immense.

Prologue

O ver the years, many prominent and capable women have contributed to the fabric of community that makes up the island of Martha's Vineyard. It certainly did not blossom and bloom by men alone. To choose the most intriguing, unusual, gifted and committed women was a challenge. The following is only a small sample of the many fine women who have lived here.

We begin in 1778, with the story of three young women of Vineyard Haven who had the audacity and courage to blow up a flagpole to prevent the British navy from confiscating it for a ship's mast. The story unfolds:

The British naval ship *Unicorn* was in Vineyard Haven Harbor in need of a replacement for a broken spar or mast. The Liberty Pole on Main Street was the tallest pole around, and the British planned to take it. Polly Daggett, Parnell Manter and Maria Allen had other plans. The story goes that at midnight they drilled a hole in the pole and blew it up, thus denying the British their spar.

No one is sure how true this story is, though the Daughters of the American Revolution did mount a plaque on a replacement pole in 1898. It could be folklore, except the three women were real and have headstones in a local cemetery. Beyond this tale, little is known of their lives.

Decades later, another young Vineyard woman stole center stage. Laura Jernegen, known as the girl on the whale ship, composed a diary of her adventures aboard the whaling ship *Roman* as it sailed across the ocean in the mid-nineteenth century. Her tale resonates today.

Laura kept a diary for three years, beginning in 1868, when she was six. Her father was captain of the whale ship *Roman*; he brought his wife and two children along on this adventure. Laura's diary is ripe with childish observations but matured as the voyage continued.

Her father left his family in Honolulu; they made their way to San Francisco and home via the new transcontinental railroad. Captain Jernegan headed into the Arctic in pursuit of whales. The *Roman* was one of forty whale ships trapped in ice; eventually, all hands were rescued, the ship sank and the Jernegen family was reunited back on the Vineyard. Laura's childhood journal is preserved in the archives of the Martha's Vineyard Museum, and her story is accessible on the interactive website, www.girlonawhaleship.org.

Through the years, Vineyard women have been abolitionists, signing petitions in the antislavery movement. Women played a role in the temperance effort to limit use of alcohol. Vineyard women worked to secure the right to vote, which is evident today with the League of Women Voters. While these historical adventures resonate with our love of the island, we need personal anecdotes and additional documentation to flesh out the stories. Many more women deserve recognition, from Betty Hough to Katharine Graham to Jackie Kennedy. Perhaps another volume on Vineyard women is necessary. At the moment, however, we relegate them to this introduction and delve deeply into the stories of women for whom we have a wider store of knowledge.

Selection for inclusion in this book was mine and mine alone. I was fortunate to contact relatives who supplemented the printed material available in Linsey Lee's *Vineyard Voices* and *More Vineyard Voices* and especially the fine obituaries in the files of the *Vineyard Gazette*. Books written by or about the women added to my store. There was no shortage of information; the challenge was to assemble the material, organize it and deliver the manuscript and photographic images to my able editors at The History Press, in a timely fashion. The publisher creates the masterpiece; I only submit what I consider worthy.

I chose to arrange the biographies in a chronological order, based on the subjects' dates of death. I could have sorted them by town, by profession, by birth date or alphabetical order, but I chose this arrangement to provide proximity of those who lived at the same time.

Thus, in the 1920s, Ms. Cornell's acting career was beginning while Emily Post wrote her landmark book, *Etiquette*. In the 1930s, Dionis Riggs researched her family history while Dorothy West traveled in Russia. In the 1950s, Lillian Hellman went before Congress, and Polly Hill started planting.

In the 1960s, Nancy Whiting drove to North Carolina while Patricia Neal struggled with a stroke. It may be of interest to compare one chapter of the chronology of twentieth-century life on the Vineyard with other chapters. Or bounce about, as each chapter, each biography, each woman stands proudly on her own.

This book is unconventional as it does not follow the typical arc of a story but consists of a series of biographies of different lives. There is consistency in that each woman felt strongly about her Vineyard roots and attachments; love of the island was foremost. Many suffered challenges from death, divorce or disease; all found solace in the calming waves and varied shoreline. Rose Styron's foreword emphasizes the attraction of the Vineyard, with personal experiences intertwined with family and friends in a delightful, natural setting.

Several women displayed a strong commitment to the theater as actresses or playwrights or in a theatrical style of writing. A common theme of sharing knowledge, through actions, words or emotions, was also evident. What made this book intriguing to compose was the variety in these women's lives yet the commonality of the strong pull of the Vineyard. "This is my home" was a phrase uttered time and again and a feeling that reflected the love and attraction for our little island.

Thomas Dresser
February 2013

Nancy Luce (1814–1890): Poet, Entrepreneur

West Tisbury

Nancy Luce lived on Martha's Vineyard her entire life, unmarried and alone, on a farm on New Lane in what is now West Tisbury. She raised chickens, tended a garden and wrote and sold pamphlets of her poetry. Her unusual lifestyle was not typical of the social fabric of the times.

Over her lifetime, she elicited both praise and rebuke. She was an eccentric character who managed to forge a place for herself in her community. For decades, her only companions were her hens. She was reviled as unusual yet wrote poetry that has a beat and a message that resonates today. Nancy Luce was a complicated individual.

A piece by historian Arthur Railton noted that "when she couldn't hand-letter the booklets fast enough to satisfy the demand, she sent a collection of her full length poems to a printer in New Bedford who produced a little booklet entitled *Poor Little Hearts*. A good title because it was Nancy who first made the heart symbol famous. But folks just smiled at the crazy hen lady and her childish poetry and her silly hearts."[2]

Railton acknowledged her wayward ways yet respected her ingenuity and fortitude in the rugged rural farmland of nineteenth-century Martha's Vineyard. "And soon this recluse, in a tiny farmhouse on a dirt lane a mile off the main road in West Tisbury, became a celebrity—the Island's first. Her writing, along with her butter-and-egg money, paid her bills. She supported herself until she died in 1890 at age seventy-five, our first successful woman entrepreneur. Our first professional writer." Railton congratulated Nancy Luce on her attributes in making a name for herself.

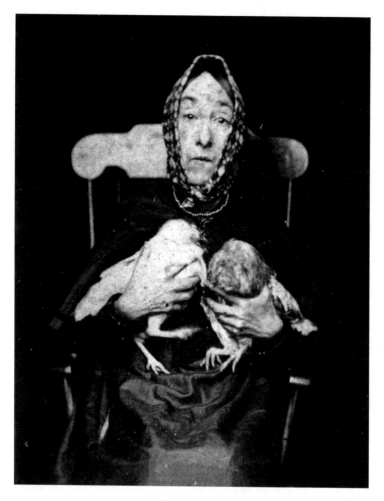

Nancy Luce seated with her beloved chickens. She had gravestones carved for her favorite hens. *Courtesy of the Martha's Vineyard Museum.*

In her younger years, Nancy was well known as a horsewoman. Apparently she was attractive, charming, handsome and a bit of a tomboy. And she had several suitors. She rode her spirited horses through the fields, jumping fences and stone walls. Her parents were well-to-do; she was well-dressed, and the family owned several horses.

Nancy Luce "became betrothed to a young seaman, and their wedding was planned to take place on his return from a voyage. But he never returned. 'Lost at sea' was the only information passed on to the relatives, his sweetheart and those who lived after. The high-strung intellect of Nancy Luce cracked from grief and strain."[3]

The loss of her fiancé was devastating. Nancy Luce fell into a depression that contributed to a lifestyle quite different from that of her youth. The news story continues: "She devoted her life to the care of her parents, who suffered prolonged illness in their latter days and eventually exhausted much of their means as a result. When they too had gone, a strange, even weird being replaced the girl who had once been the village belle. The 'crazy character' ridiculed, jeered at, despised as a human freak, by the sons of men who had once sought her favor." Moses Norton of Chilmark recalled that "a wedding was planned, but when her fiancé was lost at sea, she came apart." She cared for her aging parents but then became "weird in appearance, speech and action." These events occurred in 1840, when Nancy was twenty-six years old.

An article in the 1950s[4] attempted to reconcile Nancy Luce's unusual behavior with her upbringing. It was titled: "Nancy Luce: A Vineyard Character Thwarted in Love?" She inherited her parents' farm but little more. Besides egg sales, she encouraged tourists to take her picture and sold them poetry. "The sale of these droll pictures, and a printed effusion called *Poor Little Hearts*, with the proceeds of her cow and hens, serve to supply her wants, though her surroundings are very desolate…The house is a model of neatness." Nancy Luce personalized her eighteen hens in the homestead with names; they served as companions. She wrote, "Now my days are all dark, and these animals are all the friends I have."

According to one unnamed, undated publication, Nancy Luce was "discovered" by Rodolphus Crocker, a stable master of Vineyard Haven who recognized her potential as an attraction for tourists. "He quickly perceived the drawing power of Nancy Luce." The story continues: "Nancy Luce became famous in an instant. Pictures of her pathetic self, her hens and her lonely home soon adorned the Martha's Vineyard guide books and a stream of summer visitors constantly wended its way 'up island' from the Methodist camp ground in Oak Bluffs. The hearts of the stable keepers, of which the far-seeing Mr. Crocker was one, were made glad." Nancy Luce proved good for the business of tourism.

A sympathetic take on Miss Luce was offered by Marcia Torrey of Barrington, Rhode Island, in a letter to the editor of the *Gazette*: "My

own feeling is that her losses were more than she could bear and the loneliness she felt caused the change. With no one to turn to she bestowed all her love on her hens, and her poetry was a form of therapy for her." Ms. Torrey believed Nancy Luce expressed her emotions in writing and that her love of animals showed that "she was indeed a very sensitive person."[5] That Nancy Luce utilized both poems and chickens as a source of income indicates her resourcefulness. In the nineteenth century, it was unusual for a single woman to live alone; Nancy survived on her wits and her aberrant behavior.

Nancy was not without human contact, albeit limited to West Tisbury. She wrote numerous letters in the 1840s to a merchant, Edward Munro, that survive in a file at the Martha's Vineyard Museum. The excellence of the handwriting stands out, as does the weak spelling. The content of the letters is intriguing, from requests to purchase tobacco to those for water paints, which she resold or used herself. In September 1842, Nancy wrote, "I think it is best for me to try to make a few pictures if I can to take up my mind so that the medicines can have a chance to help me if possible. ([M]y mind is so out of order because I cant ride somwhere [sic] it damages my health and the medicines cant [sic] have so much chance to help me)." The medication was likely to relieve the grief of her broken love, her aged parents and the destitute, lonely life she led.

Another cache of letters contains correspondence with William Rotch of West Tisbury, who befriended Nancy and later administered her estate. On April 16, 1885, Nancy Luce requested to barter: "I want to know if you willing, or not, to let me have some grain, and take eggs for it, if not, I must put off all my hens, and never keep any more, and cry till I die, they must not starve, dont [sic] be concerned, you shall have your pay."

Many letters were sent to physician Dr. William Luce, no known relation. In August 1873, she wrote of her will: "I convey my land, fences, house, buildings to Dr. William Luce, for you to have after my death, to pay you to take good care of my graves, and gravestones, and graveyard fence, and bury me side of Poor Pinky, to the east of her, and get me a good grave stone to my grave." Another letter, a decade later, mentioned similar concerns. The gravestones of her chickens were as important as her own.

A small news item reported that "Miss Nancy Luce received many callers on the 4th and everything went smoothly. Last Independence day she was much annoyed by parties who were meddlesome and noise [*sic*]; so this year she called in the aid of the constable of the West Tisbury district, who peremptorily checked any attempt at riot. The bland and courteous officer also acted as usher and escorted the company in the best room."[6] Nancy Luce was not afraid to seek protection when she deemed it necessary.

Life was not always so smooth. Just a few months later, on October 24, 1870, in a letter to the editor of the *Vineyard Gazette*, she complained about visitors from Holmes Hole who bothered her with loud noise and a taunting manner: "I staggered about the house after they went for a little while forced to be careful and not fall, I was so beat out. I kept talking to them on goodness, they would not mind it…they are cruel. I want folks to call on me that has [*sic*] tender feelings for me in sickness, and not make noise to put my head in misery. A good many very nice folks calls [*sic*] on me." Nancy Luce was not averse to proclaiming her beliefs but likely it was to a disinterested audience.

Incidents erupted over the years as visitors taunted, annoyed and harassed her. She wrote to Jeremiah Pease on April 15, 1879, in reference to young boys who attempted to break into her house. Saying she felt she was being "murdered alive," she requested, "You must stop all infernal squealing, singing they call it." Her visitors probably considered it an act of compassion to visit her; she perceived it as torment.

An item in the West Tisbury police blotter reported, "Oct. 26, 1882: Miss Nancy Luce, a maiden lady who lives alone…now has a new pistol and claims she has a right to defend herself. During the last day of the Agricultural Fair, twenty carriage loads of people visited her. Some of them carried their fun a little too far by shutting their hostess in a closet, but they made up with her by purchasing a large number of her books."[7]

Visitors continued to parade out to her humble New Lane abode. An unidentified booklet, published around 1900, described the memorable atmosphere: "Many of the sedate middle aged men and women of Martha's Vineyard today will realize the meaning of this plaint, for in their childhood days a visit to Nancy Luce was a never-to-be-forgotten lark, and a treat in store to be anticipated with the annual visit to the cattle show at West Tisbury."

Her unusual lifestyle, focused on her beloved hens, intrigued her many visitors. The piece continues: "To the great majority of people who knew

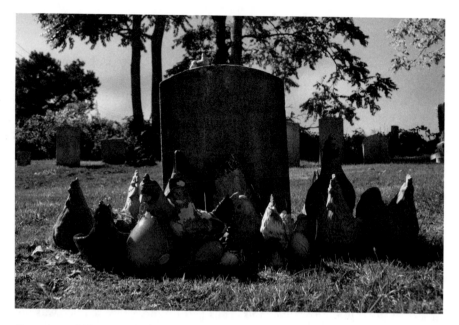

Gravestone of Nancy Luce in the West Tisbury cemetery. Small chicken statues decorate her grave year-round. *Photograph by Joyce Dresser.*

or knew of her, Nancy Luce was a fantastic character, a crazy, ridiculously behaving being, someone providing a laugh, someone to torment until she went into a fit of temper."

Hens. It always comes back to the hens of Nancy Luce. She treated them like humans, in some cases better than humans. As Samantha Barrow wrote in *Edible Vineyard*, "She eked out a living from the sale of her carefully written poems and photographic self-portraits with her hens. She was, at her peak, a bona fide celebrity, but a public figure maligned as much as celebrated during her lifetime."

Nancy Luce recorded her lonely existence in poetry and photographs, advocating protection of her beloved hens. She sought comfort in her simple life, though neighbors and visitors often denigrated her aberrant behavior.

Former West Tisbury poet laureate Dan Waters writes, "Whenever a favorite hen died, she would write an elegy to it and have a headstone made for its grave. Modern-day Vineyarders still visit and leave loving tributes at Nancy's grave, in the form of assorted ornamental chickens."

Over a half century, Nancy Luce published a number of poems and books. *Sickness, Etc.* is a twenty-four-page booklet written in 1865 that details her travails in caring for her hens and visits from the curious: "Within 13 years, 7 folks have asked me raven [*sic*] to let them come here alive, they impose on me. They would destroy everything. And drive my hens in woods, I cannot live without hens." On the last page, she wrote, "Them that calls on me, must come with good hearts, tender feelings, speak the truth, to my face, and behind my back, but gross sinners must keep away. Strive for the love of God in your hearts."

A Complete Edition of the Works of Nancy Luce was published in New Bedford in 1871, reprinted in 1875 and again in Cottage City (Oak Bluffs) in 1888. One booklet, entitled *Poor Little Hearts*, includes the tender line in the frontispiece, with Nancy's primitive illustration: "This heart with a little one in it, Is to give you to understand, That hearts can be united."

Originally printed in 1860, *Poor Little Hearts* was included in a volume entitled *Consider Poor I*, published in 1984 by Walter Magnes Teller; it was recently republished by the Martha's Vineyard Museum. Mr. Teller's intent was "to dust off and rescue from near oblivion an estimable person and poet." He did that and more.

A review of *Consider Poor I* noted that the book offers "a more sympathetic perspective of this woman, sometimes treated unfairly by history." And "from early on she was an entrepreneur."[8] She managed to live alone, wrote well and proved herself quite self-sufficient.

The last stanza in her book reads, "Them that knew me once, know me no more." Besides her poetry, Nancy Luce maintained meticulous financial records of her meager income, expenses and bartering. According to author Walter Teller, Nancy Luce actually was quite learned and skillful, at least in her poetic style of free verse:

> *And murdered alive as I am*
> *They come from Vineyard Haven and Edgartown*
> *And I feel sick my whole time*
> *I murdered so much.*

The 1878 *Guide to Martha's Vineyard and Nantucket* described her odd behavior, which made her an object of interest. The guide categorized her poetry: "It is a dreary waste of nonsense—a mere jingle of words—and yet amusing

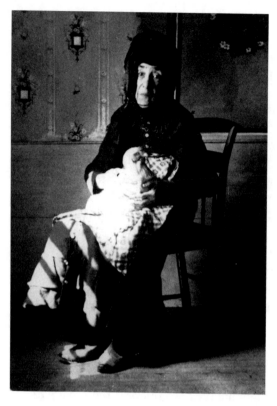

Home of Nancy Luce on New Lane in West Tisbury. Nancy lived alone for half a century, her hens her only companions. *Courtesy of the Martha's Vineyard Museum.*

from its very silliness." Nearly a half century later, opinion evolved. An article referred to both the hens and poems of Nancy Luce: "No one will deny that these are extraordinary names for hens."[9] Two favorites were Ada Queenie and Beauty Linna. The article continued, comparing her lyrical talent to "some of the much acclaimed Modern Stuff. Judging by these two samples we must say that we consider Nancy Luce somewhat superior to Carl Sandburg." (Another article on the same page of the *Gazette* reported on a woman who knitted wool sweaters for her newborn chicks.)

Through the years, the life of Nancy Luce has proved intriguing. The *Island Review* of August 28, 1878, called Nancy Luce "an eccentric old lady, who is one of the celebrities of the Island." According to the *Omaha* [Iowa] *World Herald* of October 19, 1960, she was included in *Ripley's Believe It or Not* in a cartoon of her chicken gravestones. Today, Nancy Luce might well be accepted as an eccentric artist in her own right.

When Nancy Luce was fifty years old, two little girls were born not far from her humble home. Their lives were very different from that of Nancy Luce, for they journeyed well beyond their Vineyard birthplace. While Nancy Luce lived her life close to home, in a sheltered environment, Lucy and Sarah Adams spread their wings far and wide.

Chapter 2

The Adams Sisters, Lucy (1861–1954) and Sarah (1863–1938): Performers

Chilmark

W hen Elmer Benjamin bumped his head on the doorway of his great
aunt's gingerbread cottage in the mid-1950s, it marked a blunt
collision between the nineteenth and twentieth centuries.

Elmer Benjamin was in the Methodist campground cottage, in Oak Bluffs,
to drop off his son Peter for a week's visit with Lucy Adams. Lucy Adams,
then in her nineties, was one of the renowned Adams sisters who performed
with General Tom Thumb and Barnum & Bailey's Circus in the late 1800s.

Peter enjoyed time with his great-great aunt, bunking upstairs in her
cottage just beyond the Wesley House. He fondly recalled his Vineyard visit:
"When I was twelve, my dad, Elmer F. Benjamin (we were from Wellesley,
Massachusetts), took me to Martha's Vineyard to stay with Aunt Lucy at her
Gingerbread House in the campground in Oak Bluffs. It was fascinating
for me to meet this cheerful, tiny woman, so animated and upbeat in her
eighty-plus years. And it was unique for me to be standing taller than she,
something that was very strange for me to experience." He adds, "I was kind
of astounded to think that there was an older lady that I was staying with
who was not as tall as I was, and I was twelve."

His memories are specific: "I stayed in a bedroom on the second floor
facing one of the 'spoke' paths of the great wheel that is the Tabernacle
campground, with the Tabernacle being the hub of the spoke trails. Lucy
was alone except for her docile cat that sat on the back of her wooden

rocking chair with her, as if keeping guard of this diminutive yet very able lady. Lucy shared many of her thoughts and experiences with me. At twelve, I didn't have many then to share in return."[10]

At the time, Peter knew only a smidgeon about his great-great aunt. Years later, he realized he had been in the company of someone who had experienced a unique and illustrious past and now cherished her glory days.

—•—

Lucy and Sarah Adams were born in Chilmark in 1861 and 1863, respectively. Their mother was descended from Thomas Mayhew, the first white settler on Martha's Vineyard; their father claimed ancestry from Samuel Adams, the Patriot who did much to foment the American Revolution. However, it wasn't their lineage that brought prominence to the Adams sisters but their diminutive height. Neither woman grew very tall; as adults, Lucy stood forty-nine inches and Sarah a mere forty-four inches.

Though small in stature, their lives were filled with grand experiences.

Their parents recognized the unusual characteristics of their first two daughters. Lucy was small, but Sarah was even smaller. When she was four years old, Sarah's shoe, made by their father, measured only three inches. The girls' mother marked their heights on a kitchen cupboard and soon realized how small the sisters were as their four younger, normal-sized siblings quickly surpassed them.

Lucy was the more gregarious sister, acting as the spokesperson. She recalled their school days at the Chilmark School: "We used to be in great demand

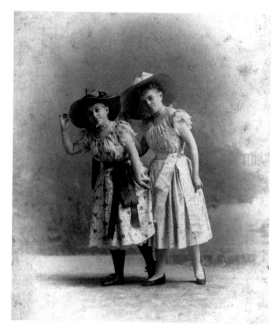

Sarah and Lucy Adams pose in their performance. Cabinet card by Schumache. *Courtesy of the Martha's Vineyard Museum.*

to play 'baby.' The girls used to hire us, giving us some childish trinket to be their babies for the summer."[11] Although diminutive in size, the girls were accepted and appreciated by their classmates.

Lucy and Sarah traveled to Plymouth, Massachusetts, in 1879 for their first public performance: a production of *Little Red Riding Hood*. A review caught the attention of Mrs. Tom Thumb, who lived in Middleborough. She shared the story with her husband, the former Charles Stratton, and soon Lucy and Sarah were invited to join Mr. Stratton, aka General Tom Thumb, in his public performances. At the time they met, Sarah and the general were the same height, forty inches.

By the age of twenty-two, in 1883, Lucy weighed sixty-four pounds and stood forty-seven inches. Sarah, then twenty, weighed fifty-one pounds and was only forty-four inches tall.

Their premier performance with General Tom Thumb occurred in New York in 1880.[12] From there, they toured with P.T. Barnum and the Barnum & Bailey Circus for several years. The sisters were determined to be recognized for their talents, not their small stature; they had no desire to be considered freaks. Lucy and Sarah rehearsed song and dance numbers and prepared acts that included singing, dancing and tableaus or sketches on a familiar theme. They would hold a stationary position while the audience acknowledged them.

As Peter Benjamin explained, "When they joined Barnum & Bailey Circus, they weren't like a freak show and they could have been promoted that way, but they weren't. They were promoted for their singing and their acting. And in their attic we found costumes for the Queen of England, the size of Lucy, angels, you name it, little costumes. All hand-made, embroidered outfits." Lucy and Sarah were bona fide circus performers.

General Tom Thumb died in 1883. Mrs. Thumb, Lavinia Bump Thumb, remarried another little man, the Italian Count Magria. Lucy Adams was invited to serve as bridesmaid for the wedding, which took place at Trinity Church, on Madison Avenue in New York, in 1885.

The fame of the Adams sisters spread nationwide. "The Lilliputian Adams Sisters are charming little ladies, extremely pleasant to address, and receive the people with a queenly grace that at once captivates all."[13] Quotes on their playbills included: "Better be small and shine than be great and cast a shadow" and "The smallest Entertainers on the American Platform today."

The *Boston Times* reported, "The Lilliputian Sisters gave a most charming entertainment. Applause was enthusiastic and complimentary remarks were heard on every hand," while the *Muffingburg* [Pennsylvania] *Telegraph*

reviewed their act, editorializing, "It is doubtful if we have ever had an elocutionist in our community that could surpass one of these sisters." Even the *London Times* commented on their performance: "The Adams Sisters are the most unique and entirely satisfactory entertainers ever in this circuit."

Their travels took them all over the American West. As Lucy recalled, "We went into many a good-sized town where there was no railroad, and most of our jumps were made by stagecoach over rough roads. The traveling was hard and unforgettable and we bounced about like tennis balls, but we

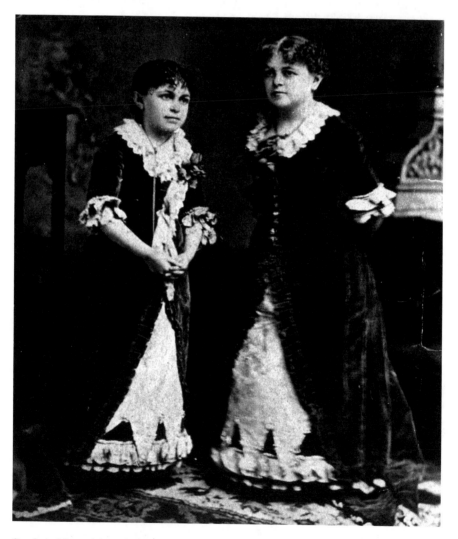

Sarah and Lucy Adams in formal attire. *Courtesy of the Martha's Vineyard Museum.*

were young and enjoyed it."[14] Over the years, Lucy and Sarah performed in virtually every state of the union. And they enjoyed their time off-stage, visiting Mammoth Cave and an abandoned gold mine.

Peter Benjamin described his great aunts Lucy and Sarah as "very prim and proper Methodists. That governed everything they did. They couldn't stand bawdy clothing, so they continued to be very conservative, following their religious directives." Raised as staunch Methodists, Lucy recalled, "We were not and aren't blue law advocates today." She explained, "But we didn't believe in Sunday performances, and that eventually did us out of a trip to Europe. They said Sunday abroad was always a gala occasion, and we'd have to play. Since we wouldn't, we didn't go."[15]

The sisters harbored no regrets for missing the European venture; they were committed to their faith. The *Vineyard Gazette* opined on their character and upbringing: "These Island girls had a solid background of a good mother, a good environment, and a good education."[16]

Their circus years were followed by participation in the Chautauqua movement of public lectures across the country, where the little women stood on stage with the likes of William Jennings Bryan. For more than twenty years, they traveled across the country. Lucy regretted not keeping a diary of their adventures, although she did pencil out a rough outline:

1880–84: New York Theatre/singing
1884–85: Lilliputian Opera Company
1885: Tom Thumb Company
1892–93: To California
1910: Santa Ana, California; Oregon; Texas
1913: Chautauqua Circuit

Neither sister ever married, though Lucy received a number of marriage proposals, according to her nephew, which she kept in a scrapbook of her suitors. "She would tell me about a book, when she was in the circus, that half a dozen of these men, individually, at one time or another, had proposed to her. And she decided to stay single. But the book meant the world to her because it had these pictures and there would be a letter and there would be a picture."

Professional touring proved an arduous career, and in the early 1900s they left the circuit to retire on the Vineyard. But retirement was hardly restful. They continued to perform at church socials and schools and found themselves in demand throughout New England. Adulation flowed in letters praising their performances. On December 15, 1915, William Lawton wrote, "Both of you were very much liked by the Mission people." On December 30, Arnie Bruce wrote, "My people enjoyed their earnest Christian spirit both in the services and as they visited in the houses. I heartily recommend them to pastors feeling the need of assistance in work with young people and children."

The Adams sisters visited churches in Providence and Pawtucket, Rhode Island; across Massachusetts; and in Connecticut and New Hampshire. On March 31, 1916, Pastor Silas Perry heralded them as "the little workers that do great things" and praised them for their "sweet and untiring manner." He added that "God has truly planned your lives to be just such as He could ask of no others."

Another minister, Pastor Albert Donnell, conveyed the feelings of his congregation on April 15, 1916: "All have spoken in the highest terms of what they saw and heard."

The *Portsmouth News* reported that "Miss Adams does not stand quite four feet, but is one of the most forceful speakers who ever spoke from the Trinity pulpit," and her voice "is as small as her self. Despite its smallness, it penetrated that great audience as the nightingale penetrates the night's air." Their programs were very well received by the public; their reserved and religious lifestyle was especially admired.

Sarah taught Sunday school at the Methodist church in Oak Bluffs. On October 17, 2012, Bob Hughes, age ninety-eight, recalled being in her class: "She, Sarah, was my Sunday school teacher. She was a good person. She was a little shrimp. She knew her stuff; good personality. Kind of normal. She sang a lot, but I didn't." Bob was not yet ten years old at the time but recalled being the same height as his teacher.

A Boston paper summarized the sisters' career: "The two sisters were on the concert stage for more than 30 years, during which time they visited all but three or four states in the union. Of late years they have devoted themselves to church work, instead of theatrical."[17]

The Adams sisters converted their family's Chilmark farmhouse to a teahouse, serving tea, cakes, sandwiches and ices. The teahouse was advertised by "the sign of the spinning wheel." Lucy sang gospel songs while Sarah accompanied her on the organ. The public was encouraged to visit for a charge of twenty-five cents. An entry in the West Tisbury Church

minister's diary observed: "The Adams Sisters have opened their interesting home for the summer as a Tea Room. Here one may not only get a delightful service of ice cream, candy, etc., but also a view of a houseful of antiques, many of which have a valuable historical value. But best of all is the pleasure of meeting the interesting people who tell the stories."

In another vein, Lucy dabbled in poetry, opining on making ends meet: "It's easily said, not so easily done, This earning a dollar, it's really no fun."

Wherever they traveled or performed, the sisters always considered their home to be the Vineyard. While they made a professional name for themselves throughout the country, it was on the Vineyard where family and friends knew them best. In an interview, Lucy Adams said, "This has always been our home." She continued, speaking for both of them: "Although we were buffeted about during our long and interesting career, we look back with no regrets. Our happiness was always complete when we could get back to the island and spend a few months roaming about the scenes of our happy childhood." The article continued: "For the Adams sisters are as dignified as their seemingly more fortunate sisters. They are real Puritan ladies."[18]

After promoting their staunch New England background, the newspaper reverted to a little hype: "Every once in a great while they emerge from retirement to appear in church entertainments and benefits being members of the Methodist Episcopal church here. Lucy teaches Sunday school in addition to other church activities. Their next stage appearance will be made February 15 [1931] when they will take part in an entertainment at the Bradley Memorial Baptist church here for the benefit of the church missionary fund." The Bradley Church was in Oak Bluffs, the church of Oscar Denniston, near the campground. The Adams sisters performed in their own community.

The teahouse ran a number of years. Unfortunately, Sarah was in a debilitating automobile accident in 1930, at the age of sixty-seven, and had to retire from public performances. She passed away in 1938 at the age of seventy-five. The Chilmark Tea House/homestead proved remote as Lucy faced the infirmities of old age. She had inherited a cottage in the Campground in Oak Bluffs and moved there from Chilmark.

Taxes on the Chilmark farmhouse at Nab's Corner proved prohibitive. Lucy called on Elmer Benjamin in the 1940s for financial assistance or advice. Her nephew was unable to provide funding but arranged for Lucy to sell the farm. Thus, she lived out her days in the little house in the campground in Oak Bluffs, near her beloved church, friends and a welcoming town. As Peter recalls, "I think it was better for Lucy, in the sense that she got to be living in the

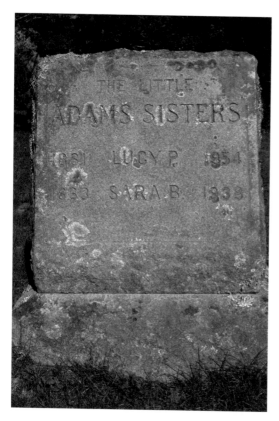

Gravestone of the Little Adams Sisters, Abel's Hill, Chilmark. *Photograph by Joyce Dresser.*

campground with her fellow congregants, Methodists."

Even in her nineties, Lucy maintained involvement in the community. She penned a letter to the Dukes County Historical Society on March 20, 1952, supporting an effort to house the lens from the Gay Head Lighthouse in Edgartown, rather than in Gay Head.

She wrote about herself and nearly a half century of public performances, "Although I am only four feet tall, and have followed a public life with my sister who was smaller than I, we were the only little people that ever had the honor of being on the Chautauqua platform." She added, "I was bridesmaid to Mrs. Tom Thumb."

In her later years, Lucy credited her longevity to drinking malted milk three times a day. As a hobby, she liked to dress up dolls. Her favorite activity was to attend church. When Peter Benjamin visited her in the early 1950s, Lucy was still a presence in the community at the Tabernacle in the campground. "Lucy was on a soapbox, the summer before she died, with her stentorian voice, presiding over Illumination Night," Peter recalled, "and I thought it was wonderful."

The Adams sisters made a name for themselves in the latter half of the nineteenth century. One who became a household name early in the twentieth century was Emily Post. The Adams sisters always considered the Vineyard their home; Emily Post summered on the island for thirty years, savoring the environment of respectful acceptance, just as the Adams sisters had done.

Chapter 3
Emily Post (1872–1960): Manners Maven

Edgartown

To some people, the name Emily Post conjures up a prim and proper nineteenth-century aristocrat, arrogantly assigning rules of etiquette to demean the middle class. Yet to those who knew and loved Emily Post, she was the antithesis of that: generous, sweet and caring. Her goal was always to put people at ease. Her story, as it relates to Martha's Vineyard, is engaging.

Emily Post may have lived a charmed life to those who did not know her, but her personal life was filled with anguish. She set the bar for proper manners, but her intent was to ease interpersonal relationships. Her obituary described appropriate activities, such as those at a dinner party: "If you picked up the wrong fork, there was a possibility that your hostess was wrong in having too many forks, Mrs. Post taught. It wasn't necessarily you who were wrong. She believed that what was socially right was what was socially simple and unaffected."[19]

Be comfortable. Put your guests at ease. Show interest rather than humiliate the person with you. Emily Post exemplified a polite atmosphere; she rebelled against random rules. And her mastery in her chosen field has survived nearly a century.

The life of Emily Post is the tale of a woman raised in high society yet brought low by her husband; later, she suffered grief from the death of a son. Her name is synonymous with good manners. How did that come about?

Emily Price was born in Baltimore in 1872. Her father was an architect who designed the base for the Statue of Liberty and her mother a former

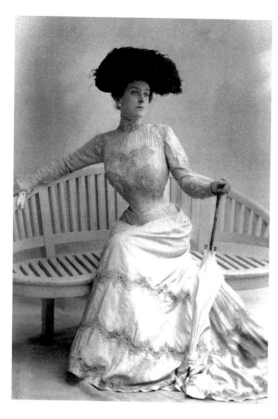

Emily on her honeymoon with Edwin Post. The marriage lasted just over a decade. *Courtesy of the Emily Post Institute.*

society debutante. Emily attended private school, and the family vacationed in Bar Harbor. When she was twenty, at a dance, her partner, Edwin Post, became so enamored by her that he proposed, and they were soon married. Two sons were born, Edwin and Bruce, but the marriage faltered and failed in 1905. It was a major scandal.

Mrs. Post was determined to succeed. She took up writing, composing magazine pieces, short stories and novels as she raised her sons. Her first book, published shortly before her divorce, in 1904, was *Flight of the Moth.* One of her more adventuresome efforts, *By Motor to the Golden Gate*, written in 1915, was a cross-country travelogue in which she recounted the automobile route from Niagara Falls to San Francisco.

In the early 1920s, Emily Post was approached to write a short book on social manners. She thought that was a ridiculous idea. Her secretary, Yvonne Sylvia, quoted her as saying, "What do I know of manners?" After much coaxing, however, she complied. The book took a year and a half to write and ran more than seven hundred pages.

Etiquette in Society; in Business, in Politics, at Home was published in a small run in 1922. It immediately propelled Emily Post to fame and fortune and a daunting future as the avatar of proper manners. Emily was fifty when she wrote *Etiquette.* She never looked back.

Once the book was published and success ensured, Emily grew into the adulation and celebrity status that followed. She made it her life's work to

update the book every five years, consistent with current fashion and social mores. (The book is currently in its eighteenth incarnation and has been reprinted dozens of times.) Mrs. Post extended her reach with newspaper columns, books and radio commentary. In a *New Yorker* interview, she was designated the bridge between upper-class society and the vast middle class. In her own terms, she defined etiquette as "the science of living. It embraces everything. It is the code of sportsmanship and of honor. It is ethics."[20]

And *Etiquette* lives on. Joan Didion wrote about the death of her husband and how the words of Emily Post were such a comfort: "In the end Emily Post's 1922 etiquette book turned out to be as acute in its apprehension of this other way of death, and as prescriptive in its treatment of grief, as anything else I read."[21] This "other way of death" referred to death in a hospital rather than at home.

Shortly after the publication of *Etiquette*, Emily Post visited a close friend on Martha's Vineyard. It was then that "she knew she was home," as Laura Claridge reported.[22] In 1927, she bought a small cottage in Edgartown, on Fuller Street, and for the rest of her life lived on the Vineyard from May to October, returning to New York City to her apartment on East Seventy-ninth Street. The Vineyard house was 150 years old and needed remodeling, which she set out to do with her son Bruce, age thirty-two, an architect like her father. Mother and son were very compatible, having designed her New York apartment. To them, the Vineyard was "the other island."

Martha's Vineyard was a perfect place for Emily Post. "She loved how her new home balanced a sense of the timeless with the temper of the modern day, the island's slightly stodgy reassurance anchored to the busyness of Boston."[23]

Shortly after mother and son began work, however, Bruce took ill and soon died of a ruptured appendix. His death devastated Emily. Slowly, she poured her grief into the garden of her Vineyard home, designing, planning and perfecting various planting arrangements. Emily could have been an architect herself had she been born in a different era; as it was, she turned her garden into an obsession and worked diligently to perfect the site. She always had a gardener to do her bidding, but she was very much in charge. Gradually, she worked through her grief. "By July [1930], the rituals and more leisurely pace of Martha's Vineyard had clearly revitalized her."[24]

That year, she published *The Personality of a House*, a book that bridged architecture with etiquette. She proposed suggestions for landscape and gardening. Humor surfaced among her recommendations: planting a half dozen different conifers is "beautiful in a moderate assortment, but all collected together suggest a group of strangers waiting for the parade to go by." Creating a small pond has merits "for those who have no fear of babies tumbling into the water, or of mosquitoes being born by the million."

Emily frowned on sharing plants with friends because the color contrast may be shocking. "To have a devoted neighbor rob her own garden to give you plants that shriek at your own plants and devastate your scheme of decoration, is about as unhappy a garden situation as can be found."[25] She maintained a detailed log of her gardening activities; with practice, she determined which plants worked well together to balance their varied colors. Behind her house was a separate garden to cut fresh flowers.

With her extensive responsibilities to update *Etiquette*, complete a daily newspaper column and respond to letters, Emily Post did much of her work in her Vineyard home. At item in *Vogue* (1933) described her affection for Edgartown: "The haven of delectable tranquility that all my life I have been searching for...It is here I write my daily newspaper syndicated articles during the summer months and store up enough vitality to carry me through a strenuous winter of writing and broadcasting in far-away New York." When interviewed for *Life*, the transformation was complete: "Emily Post has ceased to be a person and has become a noun, a synonym for etiquette and manners."[26] Her life became very busy.

Emily Post was sought after on the national stage. She joined Eleanor Roosevelt, Amelia Earhart and Lillian Gilbreth in 1934 for a Conference on Current Problems, an opportunity for successful women to discuss topics of the day. Emily worked on affordable housing for the middle class; her interest in architecture continued.

Personal problems interrupted her agenda once again when Barbara Post, wife of son Edwin (Ned) Post, divorced him in 1935.

Emily Post wrote *Children Are People* in 1940, updated in 1959. Living in Edgartown, she used current customs to dictate proper beach etiquette. Her range of topics knew no bound. Another subject became a book: *The Emily Post Cookbook*.

As time went on, Emily Post continued to share caveats about consciousness in social situations. Allowing elbows on the table while dining led her to respond, according to the *New York Times*: "If not using the arm as a lever swinging a fork or spoon from plate to mouth, it really doesn't make much

difference." According to the *Times*, her pet peeves were pretentious people, dirty silver and hostesses who served themselves first.

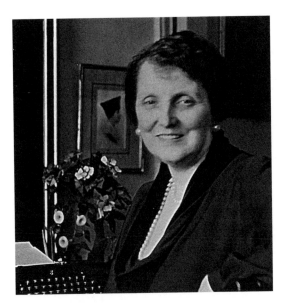

Emily Post at work on her daily newspaper column, responding to questions on etiquette. *Courtesy of the Emily Post Institute.*

"I worked for seventeen years for Emily Post," longtime secretary Yvonne Sylvia says proudly. Yvonne graduated from Boston's Faye Secretarial School in 1941 and learned that Emily needed a secretary. She was hired and worked through that year but had to relinquish the position when she married and moved to Boston, as her high school sweetheart/husband, Donald, entered the service. After the war, however, Yvonne returned to the Vineyard and worked there, for Emily, from 1945 until her death in 1960.

Emily Post's routine in Edgartown was to rise early yet remain in bed and work. She made detailed corrections and revisions to her books. Much of her work revolved around her daily etiquette column. When the work was done, and it was time for lunch, Emily pushed a button to summon a servant. In the afternoon, she might venture out to watch a Shirley Temple movie.

"She was the sweetest!" Yvonne recalled. "I used to put my baby in the carriage and go up and use her Dictaphone and typewriter in her bedroom, and work all day." Emily's column ran in 150 newspapers, and it was Yvonne's responsibility to type it up. (The column was later assumed by Peggy Post, wife of Emily's great-grandson.)

Yvonne teased Emily about her social register, calling it "your Bible." Emily gave Yvonne a crib, clothes and a baby carriage; paid for a sitter and camp; and bought her new outfits. Yvonne and Donald had five kids. "Very sweet and generous," repeats Yvonne. "She kept the same employees for years. She'd say, 'Here's a check, go get yourself a new hat.'"

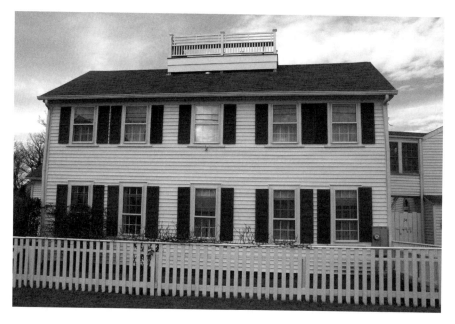

The Fuller Street house in Edgartown where Emily Post summered from 1927 to 1960. *Photograph by Joyce Dresser.*

Health issues crept into Emily's life in her early sixties. She celebrated one Fourth of July with her grandson. "When she and Bill watched the fireworks together at Martha's Vineyard, she was startled: the blasts were much nearer this year than usual, so close they seemed threatening."[27] Her vision was blurred, and she had double cataracts. Surgery proved successful. Ned realized his mother was now even more aware of color in her world.

"Color, always a pleasure to her, now became a vital part of her life, compensating for the dull glaze her damaged eyes spread over everything."[28] She took to painting interior furnishings in vivid colors. Emily Post also made a fashion statement with her clothes, where outfits and shoes often matched. She loved her red shoes. Her bedroom was wallpapered in crimson. Yet in her garden, she disapproved of red, fearing it would overshadow the other flowers. It was said she would even match her parasol to the phlox in her garden, as pink was appropriate. Emily was "particularly opinionated and strong-willed about her garden plot."[29]

Aspects of Emily Post's life could be a challenge for those around her. When she wanted to revise a project, it had to be completed immediately. Grandson Bill recalled, "And when Grandmamma wanted something done,

she wanted it done yesterday."[30] Ned referred to his "commanding mother" and her influence on the world around her. She expected her wishes to be granted as soon as possible. One wish apparently not often granted was a good night's sleep. Emily Post suffered chronic insomnia.

Her secretary recalls that Mrs. Post loved jigsaw puzzles, some imported, with handcrafted pieces. Doing a puzzle was a source of relaxation, taking her away from the pressures of the job.

Always, her kindness and generosity were evident. Employees enjoyed working with her: "More than Manhattan, Martha's Vineyard, with its seasonal, less formal attitude, allowed Emily to blur the boundaries between workers she employed and island friends."[31] Emily employed a number of people, like Yvonne Sylvia, from gardeners to maids to secretaries, and without exception they respected and revered her.

She would walk down the street with Hilda Ogren, her maid and confidante, for an ice cream soda or to the movies. "Yet in many ways, Hilda was more of a companion than a maid, a paid friend, who, conveniently, never forgot her place."[32] Emily Post loved being on Martha's Vineyard, especially when she could be with her grandchildren. As the years went by, and more grandchildren arrived, she had bedrooms added, which became known as the Annex.

In 1946, Emily Post and her son Ned founded the Emily Post Institute, where problems of gracious living were studied and books updated. Mrs. Post trained the staff herself. The institute, located in Vermont, today is a thriving operation where new books, seminars and various programs are created. As Peggy Post says, "Emily Post left a legacy with the Emily Post Institute."

Over the years, the one constant for Emily Post's life in Edgartown was her garden. It always drew a lot of curiosity from visitors, and even tour buses would slow to savor the lovely gardenias and hollyhocks. If the spirit moved her, Emily would invite passersby in for tea. When she was asked to invite a group to tour her house, secretary Yvonne convinced her to upgrade her kitchen with new appliances. Emily readily complied.

In the last years of her life, Mrs. Post composed a series of columns about manners on the road. She was aghast at the anger, the road rage, exhibited by people behind the wheel. Perhaps because she never drove, she sought to make driving more pleasant for all parties.

An apocryphal story of the late 1940s recounted a neighbor who apologized for her children's noise. "I hope you could sleep, Mrs. Post," the worried neighbor said. "My dear," Emily answered, "it is I who should

apologize to you for my snoring."[33] Apparently, her snoring could be heard all along Fuller Street!

She never felt comfortable with television, perhaps because her eyesight had weakened. In her final years, she became more absent-minded, and dementia predominated.

Emily Post died in New York City on September 25, 1960. She was certainly a daughter of the Gilded Age but also a product of an age when the middle class rose in prominence and high society lost its dominance on society. People recognized a sympathetic ear with the suggestions of Emily Post; it was her goal to use proper manners to put people at ease.

Part of her legacy is the value she placed on the middle class, including immigrants, as members of society. As the *New York Times* wrote, "No one should do anything that can either annoy or offend the sensibilities of others. Her name became synonymous with good manners."[34]

After her death, the family reduced the size of the garden yet maintained a gardener. Landscaper Tony Bettencourt was employed to keep it as stunning as it had been. (One assignment was to protect a pair of rare dahlias from the days of Emily Post.) When the property changed hands in 2001, the new owners continued the tradition of Mrs. Post to host fundraisers in the garden. And of course, tourists still pass the house, pausing to pose for photographs by the garden.

Work at the Emily Post Institute continues. Peggy Post and sister-in-law Cindy Senning together wrote a developmental parenting book, *The Gift of Good Manners*, as well as ten children's books. The most popular one is *Emily's Everyday Manners*.

The name Emily Post lives on with her mantra to be kind to one another, use common sense and, above all, make one's guest feel at ease. Although they never met, Peggy Post epitomizes the love of the practical, the spirit of Emily Post: "She was pretty special. Emily Post's legacy lives on." Peggy enjoys sharing the stories and messages of her mentor. "People love to hear about Emily Post, especially that generation over forty. She was so real. She was practical. She made people feel comfortable. Emily Post was really down to earth."

Like Emily Post, another nationally known woman chose the Vineyard for a vacation respite. Katharine Cornell loved the Vineyard as much as Emily Post for its seclusion and beauty, not to mention the respect shown to celebrities.

Chapter 4
Katharine Cornell (1893/98–1974): Actress

Vineyard Haven

"M iss Cornell used every minute of her time on the Vineyard," a local newspaperman wrote, "and over the years became one of its primary boosters and benefactors. She loved picnics and clambakes and softball games, in which she immersed herself with the grace of a natural athlete."[35]

What enticed a nationally known actress to come to Martha's Vineyard, build a house in the 1930s and choose to die here forty years later?

The draw of the Vineyard was intense.

The commentary continued: "I always loved Martha's Vineyard," the actress once said. "I've lived here through hurricanes. I've loved every minute of my time on this island, winter or summer, rain or shine."

It was the calmer days on the Vineyard that she appreciated. "Often, in later years," the article added, "she could be seen in slacks or jeans doing her marketing with her fellow townspeople in Vineyard Haven." As a celebrity, she chose not to stand out, yet she did.

The town selectmen could not contain their admiration for Miss Cornell. The Tisbury Town Report for 1974, the year she died, bore the following tribute: "A lovely lady, beloved by all, this was our Miss Cornell. Katharine Cornell has been an important part of our Community for many years. Every summer we would look forward to her arrival and her cheerful greetings to everyone on Main Street. We would hear up and down the Street, 'Miss Cornell has arrived.'"

The selectmen, Manuel Maciel, Frederick Thifault and Craig Kingsbury, expressed their emotional bond to her: "We never thought about losing

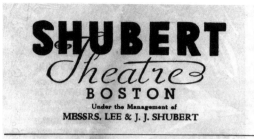

Playbill featuring Katharine Cornell at the Schubert Theatre in Boston. *Courtesy of the Tisbury Town Hall.*

Miss Cornell. Somehow, we believed she would be with us always—and so she will. Memories of her will live on forever and ever since time can never erase her gracious and friendly smile. A famous actress she surely was, but in our hearts she will always be our friend."

As a dramatic actress, Miss Cornell dominated her milieu. Her ability to assume character was unquestioned. Her classic looks and stature, combined with superb acting, had no peer in the early half of the twentieth century.

Katharine Cornell's acting career started inauspiciously in 1917, working in stock shows in Detroit and Buffalo. She got a break with a role in *Little Women* in London, which led to a role in Clemence Dane's *A Bill of Divorcement* in New York in 1921. The play ran two seasons.

Behind many a prominent woman stands an influential man. Katharine Cornell owed much of her opportunity as a stage actress to her husband, Guthrie McClintic. Her debut on Broadway was observed by McClintic, a young director who recorded his initial impression of Miss Cornell: "Interesting. Monotonous. Watch." McClintic directed her and married her, and their relationship lasted forty years.

Miss Cornell assessed the role of her husband: "If not for Guthrie, I think I would have continued just drifting. He wanted to be an actor, and my

career was a sublimation of his desire because he could pour his talents through me, and that was a great advantage to me." He was the one "who gave me the confidence needed."

The roles she assumed over the years varied greatly. In 1925, she starred as a provocative leading lady in *The Green Hat*. Later, romance was her forte. Her prominence was well ensured by the 1930s, when she formed a production company, Katharine Cornell Presents. Her first play, *The Barretts of Wimpole Street* in 1931, explored the love affair of Elizabeth Barrett and Robert Browning. Over the years, that play, more than any, became recognized as Miss Cornell's signature performance.

Brooks Atkinson, of the *New York Times*, critiqued the show: "[The play] introduces us to Katharine Cornell as an actress of the first order. Here the disciplined fury she has been squandering on catch-penny plays becomes the vibrant beauty of finely wrought character…Her acting is quite as remarkable for the carefulness of its design as for the fire of her presence."

After a year on Broadway, Katharine Cornell Presents traveled around the country in the 1930s. It was the depth of the Depression, yet the troupe visited over seventy communities in a twenty-thousand-mile extravaganza. "We opened up the road," Miss Cornell enthused, "*The Barretts* never played to an empty house…we came back having more than broken even. We really felt prideful."

Over the years, she would perform in New York and then take her show on the road, giving the heart of the country an opportunity to see her. It was an act of generosity, as well as a chance to vary her routine. One memorable event exemplifies the loyalty and affection her audience felt for Miss Cornell.

The troupe was headed to Seattle on Christmas day. Her train was held up by floods, so when they were supposed to go on stage, they were still many miles away. The players realized they would miss the performance and their pay.

It was after 11:00 p.m. when the train pulled into Seattle. To the amazement of Miss Cornell and her cast, the audience was still in the theater, awaiting their arrival. The show began at 1:00 a.m., and the experience was recounted by Alexander Woollcott, of the *New Yorker*: "The excitement, the heady compliment paid by the audience in having waited at all, acted like wine on the spirits of the troupe and they gave the kind of performance one hopes for on great occasions and never gets." That exemplified the draw of Miss Cornell.

Still shot of Ms. Cornell at a fundraiser for the Martha's Vineyard Hospital, from the movie *This Is Our Island. Courtesy of the Tisbury Town Hall.*

In the years prior to World War II, at the height of her popularity, Miss Cornell chose to build a summer house on Martha's Vineyard. She selected a spit of land in Tisbury, right on the shore, between Lake Tashmoo and Vineyard Sound. She purchased her property through a straw buyer in 1936, fearful that if locals knew it was desired by the nationally known Katharine Cornell, they would raise the price. She hired Eric Gugler as the architect, and the house, named Chip Chop, was constructed prior to the summer of 1937. Miss Cornell sought a rustic retreat with neither telephone nor electricity. It was, according to biographer Tad Lesh, "on a spit of land with water on three sides and a primitive path down the middle."[36] Later, the Great Big Room, forty by seventy-five feet, was added, as was a pair of guesthouses. Katharine imported a loom so she could do marquetry, weaving fabric for Guthrie's sports coats.

The Great Big Room became the centerpiece of Chip Chop, which boasted two gothic fireplaces, an expansive dining table and chairs imported from a monastery in Europe, a grand piano and a ping-pong table, all housed in a room that featured wooden beams and wooden ceiling planks. It was reviewed in a popular national magazine: "Both sides [of the long room] are open to the sunset over Vineyard Sound and the moon rising out of Lake Tashmoo."[37]

Aase Jones, secretary to selectmen in Tisbury, has been in Chip Chop. She found it very comfortable, with lots of cubbyholes, plenty of space and gorgeous views of the water and of Lake Tashmoo. "It's a very comfortable home," she says.

The most dangerous incident in the house occurred in the autumn of 1938 when ocean waves, raised by the hurricane pounding up the coast, pushed through one wall of the house and Miss Cornell had to open the doors to let the water pour out the other. It was such a dramatic scene that she had to be rescued from Chip Chop by the U.S. Coast Guard.

World War II interrupted Katharine Cornell Presents in the States, but Miss Cornell took her production overseas for the USO. In the autumn of 1944, Katharine and her friend Nancy Hamilton produced *The Barretts of Wimpole Street* in Italy and Paris for the Allied forces. They offered more than 140 performances. Nancy Hamilton was wardrobe mistress for the shows.

Nancy Hamilton's niece, Sally Hamilton, says, "I think that was a high spot for Kit's [Katharine] and Nancy's life. They entertained the troops with skits, at least Nancy did. They went through hospitals with wounded soldiers and faced many hardships." The experience proved most rewarding.

One amusing sidelight was that in Paris, Gertrude Stein and her partner, Alice B. Toklas, sought to see the show but were not permitted, as it was designated solely for GIs. The women simply donned GI attire and appreciated seeing Katharine Cornell in her Paris performance.

After the war, back on the Vineyard, Katharine and Nancy reprised their show at the Association Hall (now the Katharine Cornell Theatre) in Vineyard Haven. Gregory Peck joined Kit and Nancy for the Vineyard event.

A brief news clipping in the *Vineyard Gazette* announced that Katharine Cornell and Guthrie McClintic sought screen rights for Cecil Smith's *Florence Nightingale*. "Miss Cornell, due soon at her Vineyard home, Chip-Chop, after a trip to Spain, is already scheduled to appear in *Main Street to Broadway*, the Council of Living Theatre film." (Apparently, the Florence Nightingale movie was never produced. Nor did Katharine Cornell or co-star Gregory Peck appear in *Main Street to Broadway*, although they had initially been

The Katharine Cornell Theatre, formerly Association Hall. The lower level is the Tisbury Town Hall. *Photograph by Joyce Dresser.*

scheduled to do so.) The movie, with a different cast, was a fundraiser to promote live theater; it was released to poor reviews.[38]

Through the years, a question had been raised about the precise date of Katharine Cornell's birth. She was an only child, born in Berlin; her parents were from Buffalo, New York. For years, she said her birthday was February 16, 1898; later, in her seventies, she offered the year as 1893, explaining: "When an actress is younger she likes to lower her age, but when she is older she likes to add to her years."

As her professional career waned in the 1950s, it seemed to many observers that Miss Cornell had lost her dazzle. She reluctantly appeared on radio and television but felt uncomfortable in either medium; the live stage was her forté.

In 1961, the relationship that had blossomed in the 1920s withered with the death of Guthrie McClintic. He had directed her, chosen her productions and provided unyielding support for forty years. With his death, Miss Cornell effectively retired from the stage; she could not face acting without him.

When Guthrie passed on, Nancy Hamilton stepped in and picked up the pace in Katharine's final years. Nancy had co-written the play *One for the Money* in 1939 and earned an Academy Award for her documentary on Helen Keller, narrated by Katharine Cornell. Nancy proved a lively, exciting advocate and friend for Miss Cornell. "Nancy Hamilton brought a talent for fun—and has always said she found in Kit one of the funniest

women she has ever known."[39] "She kept Kit's life lively," recalls Sally Hamilton. "Nancy enjoyed parties. When she came in, it was a laugh a minute."

Katharine sold Chip Chop in 1968 (it is now owned by Mike Nichols and Diane Sawyer) and moved into a renovated barn on the property. "Nancy created attractive living quarters out of the barn that had been the center of Kit's victory garden in World War II." An abandoned lighthouse served as a bedroom in the Barn, and later a swimming pool and putting green were added. The Barn was near the original house but required less upkeep. It was "sheltered, snug, and less exposed to the elements than Chip Chop."[40]

In 1969, Katharine Cornell arranged a boat trip through the French canals. She invited friends, some from the Vineyard; it proved a memorable adventure.

When Nancy suggested that Miss Cornell hire someone to paint a picture of Chip Chop, Kit commissioned Stan Murphy. She was so happy with the result that she doubled what she had agreed to pay, pointing out that Chip Chop was arguably two houses joined together.

As the 1960s drew to a close, the townspeople of Tisbury set plans in place to recognize the 300th anniversary of the 1671 founding of the town. Nancy Hamilton and Katharine Cornell played a role in making it a memorable event.

Association Hall, on Spring Street, was built as a Congregational church in 1844 but was later used by Unitarians. The Vineyard Literary Association held forth in the latter part of the nineteenth century, hence the name. Association Hall was renovated and repaired for the town's 300th anniversary in 1971. Katharine Cornell was instrumental in funding the restoration.

As Sally Hamilton recalls, "She [Katharine] did a huge amount for the Vineyard. She commissioned, or had commissioned, the Stan Murphy murals. She did very much to help his career." He painted four massive murals for the walls: one is the *Moshup Legend of the Indians*, another is *Winter on the Vineyard*, the third features elements of whaling and the fourth is *Tisbury, Then and Now, 1671–1971*, suitable for the tercentennial.

In the Town Report for 1971, the selectmen wrote, "Words cannot adequately express our gratitude but the auditorium is being used and visited with pleasure and pride," and "there are few things more satisfying than bringing out the beauty of an old building and making it live again." The selectmen later renamed the building the Katharine Cornell Memorial Theatre.

Also in honor of the celebration, Nancy Hamilton produced a film to celebrate the Vineyard entitled *This Is Our Island*. It was a collection of fifty years of movies by Vineyarders, as well as current shots. Katharine Cornell narrated *This Is Our Island*. There is a memorable scene of her pitching a baseball for a hospital fundraiser. Background sounds include the Vineyard Haven Band. The town report for 1971 gushed, "The film is remarkable, its myriad pieces put together with great skill, taste, humor and affection for the Vineyard and Vineyarders. It will be a much valued record for the future." (The movie is shown at the discretion of town hall leaders.)

Three screenings of *This Is Our Island* in early July 1971 produced proceeds to establish a maintenance fund for Association Hall, which doubles as the Tisbury Town Hall. The Tisbury Street Fair was held on July 8 to commemorate the founding of the town as well and is held on that date each year.

Katharine Cornell was very generous, as spelled out in her biography: "She became known to all the islanders, most of whom called her 'Katharine,' and she was so at ease in her charmed retirement that she even enjoyed her own celebrity, reacting with spontaneous delight and more than a little showmanship, to the sudden attention paid to her in public places."[41] At her eightieth birthday in 1973, she basked in the celebratory role. Aase Jones, of Tisbury Town Hall, says, "She had a neat talent, very impressive."

Katharine Cornell supported Vineyard ventures, from the local animal shelter to donating $200 to the Rice Playhouse when it faced financial ruin in the summer of 1940. She cared deeply for the Vineyard. Bob Hughes, age ninety-eight, recalled meeting her, calling her a great actress and quite beautiful.

Miss Cornell was presented the National Artists Award, which praised her "incomparable acting ability and her theatrical genius." The medal affirmed that Miss Cornell had "elevated the theater throughout the world." A room at the New York Public Library's theater collection at Lincoln Center was dedicated to her and Guthrie McClintic.

While in New York, in the late spring of 1974, Katharine took ill and requested to be flown to the Vineyard. She died in the Barn on June 9, 1974, and is buried behind the Katharine Cornell Theatre. A stone bench and memorial are dedicated to her memory.

The obituary in the *New York Times* broke the news to the nation: "Katharine Cornell, one of the great actresses of the American theater, died at her home in Vineyard Haven, Mass., on Martha's Vineyard. She was 81 years old."[42] Critic Alexander Woollcott considered Miss Cornell the "First Lady of the Theater."

While Katharine Cornell was the leading American actress of her era and found solace on the Vineyard, the dramatic playwright Lillian Hellman also found tranquility and satisfaction on Vineyard shores. Ms. Hellman spent many summers in Vineyard Haven, enjoying the same comforts as Miss Cornell. Both Katharine Cornell and Lillian Hellman lost their partners in 1961, which seemed to redouble their allegiance and involvement in the Vineyard lifestyle.

Chapter 5

Lillian Florence Hellman (1905–1984): Playwright

Vineyard Haven

Lillian Hellman first worked as a book reviewer, later read scripts in Hollywood and then blossomed as a nationally recognized playwright with *The Children's Hour* in 1934. She had a close relationship with longtime companion Dashiell Hammett until his death in 1961. For many years, Lillian Hellman summered in Vineyard Haven, where she died in 1984. She is buried at Abel's Hill Cemetery in Chilmark.

Lillian Florence Hellman was born in New Orleans on June 20, 1905, the daughter of a shoe salesman; her mother was descended from a prominent banking family. In 1910, her father relocated to New York, yet Lillian always maintained a strong affinity for New Orleans. She attended classes at both New York University and Columbia University and then worked at the *New York Herald* in 1925, writing book reviews. Within five years, she advanced to script reading at Metro-Goldwyn-Mayer in Hollywood, earning fifty dollars a week.

Although she married playwright Arthur Kober in 1925 (they were divorced seven years later), the real love of her life was mystery writer Dashiell Hammett, whom she met in 1930 and remained intimate with until his death. Hammett, author of *The Maltese Falcon*, proved a forceful influence on Hellman throughout her life. He encouraged her to write *The Children's Hour* (1934), based on a student's accusation of lesbianism in a Scottish boarding school. With nearly seven hundred Broadway performances, *The Children's Hour* propelled Lillian Hellman to national recognition.

Little Foxes (1939) proved her most popular play; it recounted the downfall of a Southern family due to financial malfeasance and psychological conflicts.

In the 1940s, Lillian had occasion to rent a succession of houses on Martha's Vineyard, first summering at the East Pasture in Gay Head and later leasing a house in Menemsha, where she hooked up with longshoreman Randall Smith. In the 1950s, she again rented a house on Martha's Vineyard, this time in Vineyard Haven.

Controversy followed Lillian Hellman and Dashiell Hammett. Hammett supported the Civil Rights Congress, an organization that encouraged voter rights for communists. He was a trustee of its bail fund. When he was subpoenaed in federal court, he refused to name fellow contributors to the fund and was found in contempt. He served six months in a New York jail, from late July 1951 to early 1952.

No sooner was he released than Lillian received a subpoena to appear before the House Un-American Activities Committee (HUAC) in May

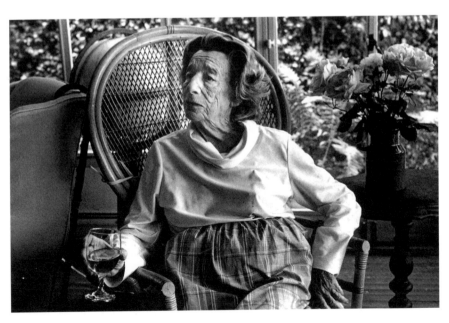

Lillian Hellman at home. *Photograph by Alison Shaw for the* Vineyard Gazette *in June 1981.*

The Mill House, Vineyard Haven, was the home Lillian shared with Dashiell Hammett. *Photograph by Joyce Dresser.*

1952. She agreed to testify but refused to name names and would not plead the Fifth Amendment protecting against self-incrimination. In a letter to HUAC, made public in the *New York Times*, she stated she would speak for herself but not divulge anything about anyone else.

Lillian wrote on May 19, 1952, "But to hurt innocent people whom I knew many years ago in order to save myself is, to me, inhuman and indecent and dishonorable. I cannot and will not cut my conscience to fit this year's fashions."

Pleading the Fifth could not happen once you admitted to any involvement in the party. Being a communist, at the time, was a criminal activity. (Lillian Hellman may well have been a secret member of the Communist Party in the late 1930s and then dropped out in the 1940s.) The *New York Times* reported that she had rebuked the HUAC with her letter, which was considered a triumph. Although she was not jailed, she was blacklisted, which proved a financial and public relations issue.

Though blocked from the theater scene for a number of years, Lillian managed to work her way back in with her play *The Lark*, based on the trial of Joan of Arc. The success of this play on Broadway in 1956 provided Lillian the finances to purchase a house in Vineyard Haven. She bought the eighteenth-century former gristmill on three acres of shoreline; it overlooked Vineyard Haven Harbor and boasted a private beach.

Lillian once said, "It was water, not writing, that drew me here." She grew quite attached to life on the Vineyard and confided in a letter to Irene Worth that she "loved this island and this house the way you sometimes love when you get something you want that you never thought you'd have again."

Known as the Mill House, complete with a tower, she had found her summer retreat. "She had always wanted a room where she could roll right out of bed to a typewriter," Henry Beetle Hough noted in the obituary for Ms. Hellman in the *Vineyard Gazette*. In the course of renovations, she had the attic converted into a writing studio. And that is where she wrote her powerful play about a New Orleans family torn asunder by money woes and marital infidelity. *Toys in the Attic* opened in 1960.

The Mill House was down a lane from the Vineyard Haven Library, visible from the ferry. Cary Scheller's grandfather had purchased an old mill, transported it next to his house and then attached it. In *More Vineyard Voices*, Cary described the situation: "Lillian Hellman bought the Mill House from my mother. And then she built the house down on the beach, because Dashiell Hammett had died in the Mill House and she couldn't live there. Too upsetting. I knew her, Lillian, as well as I wanted to. I was not a great admirer." (The property included beachfront, as well as acreage all the way to Main Street. Lillian got it for $22,000.) Cary says, "You can't buy an outhouse for that now. It was cheap then, too. Very."[43]

When Hammett died in 1961, Lillian sold the Mill House. She then had a smaller house built above the beach; it was a modern house, with two levels, lots of glass and two ocean-facing decks. "The house, with its toned down modernity smacked more of Malibu than Martha's Vineyard, where deviations from the weathered shingled New England style were rare."[44] Life after Dashiell Hammett was as active as before, with Lillian spending half the year in Manhattan and the other half on the Vineyard. She took up teaching at Harvard, MIT and NYU. Generally, she wrote in the morning and then swam or fished in the afternoon.

Another Vineyard woman, Ann Hopkins, recalled her association with Lillian: "I worked for Lillian Hellman for three years. She stayed about six months, from the middle of May to the middle of October every year. I had no complaints about working for her. People have said she was bad-tempered, unfair, this, that and the other, but I did not find her that way at all." Ann spoke about the positive aspects of Ms. Hellman: her high standards, good pay and disinterest in correspondence, "but I did not expect to be her friend. She was my employer. I thought it was nice enough that she gave me very good lunches and we went out in her boat a couple of times

fishing and I got to fly to Boston with her once when she chartered a plane and asked me if I'd like a ride."[45]

Photographer Alfred Eisenstaedt, of the Vineyard, remembered her: "My God, there are so many I have photographed—hundreds, hundreds. I photographed Mr. Hersey in Vineyard Haven and so on. Ruth Gordon and Kanin. Lillian Hellman, very difficult. She moved always."[46]

Lillian Hellman was always conscious of how she was perceived. Over the course of several years, she penned three autobiographies to tell her story from her perspective. *An Unfinished Woman*, written on Martha's Vineyard in 1969, was edited by Chilmark's Stan Hart, who worked for Little, Brown & Company. It was essentially an autobiography but without a focus on the theater. Her second autobiography, *Pentimento*, in 1973, offered portraits of influential contacts in her writing. And the third effort, in 1976, was entitled *Scoundrel Time*, which was her account of the HUAC experience with McCarthyism. Thornton Wilder suggested she memorialize Dashiell Hammett with a fictional account of his life, but Lillian resisted.

On the Vineyard, she hosted many cocktail parties and attended her share, always with a cigarette casually in hand. Never one to sit on the sidelines, Lillian spoke bluntly to National Security advisor McGeorge Bundy on the buildup of the Vietnam War. She founded the Committee for Public Justice to justify her beliefs with like-minded supporters. Ironically, she felt Nixon's henchmen broke into the Democratic headquarters in 1972 because FBI director J. Edgar Hoover refused to do the dirty work of spying on the Democrats.

As the years passed, Lillian enjoyed the plaudits of her illustrious career as a playwright: "She had a fine summer [1977] accepting honors and degrees, entertaining friends at her house on Martha's Vineyard, bottom-fishing for scup and flounder, infuriating her fancy neighbors by forbidding them to cross her property to get to the beach, and counting the royalties of the book [*Scoundrel Time*]."[47] Friends on the Vineyard included Rose and Bill Styron, Jules Feiffer, Barbara and John Hersey, Jerome Weisner and Robert Brustein.

Even in her later years, Lillian confronted issues head on. Diana Trilling believed Lillian Hellman had the power to make or break a newcomer into or out of the community using her arrogance. In 1976, Diana Trilling spoke of Lillian's influence: "Lillian was the most powerful woman I've ever known, maybe the most powerful *person* I've ever known."[48]

The "Julia" story in *Pentimento* apparently was an adaptation of another person's life. The story closely parallels the life of Muriel Gardiner, a member of the anti-Nazi resistance employed at the psychiatric department in a local university. Muriel Gardiner Buttinger published her memoir in 1983; the

Lillian Hellman is buried in Abel's Hill Cemetery in Chilmark. *Photograph by Joyce Dresser.*

truth of Lillian's story was questioned. (*Julia* was made into a movie in 1977, starring Jane Fonda and Jason Robards.)

And Lillian brought suit against a critic, Mary McCarthy, regarding disparaging comments Ms. McCarthy voiced on the *Dick Cavett Show* in 1980 about the veracity of Lillian's work. The suit was still pending at the time of Ms. Hellman's death in 1984.

She even took on the local utility service. In a letter to the *Vineyard Gazette* regarding the telephone company, Ms. Hellman wrote, "My name is Lillian Hellman. I would like to ask you to join me in signing this letter to the Telephone Company. We wish to protest the equipment that the Massachusetts Telephone Company owns on this Island. We pay high rates, but we get bad equipment and bad service. In this summer 1983, I, Lillian Hellman, have proof that out of 67 long-distance calls, more than 39 were interrupted, either because I could not hear or a disconnection happened. There is great difficulty in local calls as well."[49] William Wright believes this complaint was as much an acknowledgement of her own auditory issues as it was a public concern.

M.J. Munafo, artistic and executive director of the Vineyard Playhouse, had the opportunity to meet Lillian Hellman in the early 1980s. She says, "My first full-length play I directed at the Playhouse was *The Children's Hour*. I met her. She was lovely to me." That same year brought a screening of the film version of *The Little Foxes* at the West Tisbury Grange Hall. Lillian was then wheelchair bound, weakened by emphysema after years of heavy

smoking. She attended and, though partially blind, feeble and ailing, spoke passionately about the play and was warmly applauded.

She always enjoyed spending time on the water, the initial reason she chose the Vineyard, and one of her final requests was to plan a fishing trip.

When Lillian died on June 30, 1984, her obituary made the front page of the *New York Times*. Although an elaborate memorial service was discussed, it was the intimate burial in Chilmark on July 3 that brought friends to her graveside to say goodbye to their dear friend.

Dozens of prominent people gathered at Abel's Hill. *Vineyard Gazette* editor Henry Beetle Hough gave Lillian's obituary front-page billing: "Lillian Hellman Is Buried Here Today on Beloved Island." He wrote, "Distinguished among playwrights, and in professional and popular opinion alike the most distinguished of all during the period in which she lived."[50] Hough continued, "Miss Hellman never stinted her interest in the theatrical efforts of the Vineyard and she was always accessible and friendly to *Gazette* reporters."

On the editorial page, Hough expanded his admiration: "Miss Hellman did not write at length or in descriptive process about the Vineyard, but it figured as a point of reference and throughout her memoirs as important." Hough recalled how she spoke of the retirement community on the Vineyard. "Miss Hellman expressed or directly spoke her mind and the Vineyard she loved most was not above criticism." She wrote, "The Islanders are equally too impressed by retired people. It's time to say that some retired people, of course, are very bright, but also to ask oneself if some retired people are not very bright, and maybe business didn't want them anymore."

Julia Wells reported on the service at the cemetery, with laudatory remarks flowing.[51] John Hersey went right to Lillian's soul: "I'd like to say a few words about Lillian's anger. Most of us were startled by it from time to time. Anger was her essence. Anger lived in her taste buds; she loved horseradish, mustard, Portuguese sausage! What a hot woman!" He said her anger was against injustice in the world; that was her primary rage.

Bill Styron remembered his last dinner at La Grange, just the two of them: "We carved up a few mutually detested writers and one or two mediocre politicians." He recalled the cackle of her laughter.

Patricia Neal recollected that she debuted her acting career, at age twenty, in a Lillian Hellman play: "I will always love my Lillian Hellman." She added that Lillian had recently attended a party in New York City for her daughter, Lucy. "Lillian wore a magnificent Russian amethyst necklace. She looked divine."

Jules Feiffer remembered Lillian: "She could take a marketing trip to Cronig's and string it out into three well-made acts, quietly dramatic, surprisingly suspenseful." In her will, she created the Lillian Hellman Fund to advance arts and sciences and the Dashiell Hammett Fund to advance political causes.

A dozen years after her death, William Wright wrote about the endurance of Lillian Hellman in "Why Lillian Hellman Remains Fascinating": "[T]here is still so much of Lillian Hellman around, it's beginning to appear that she beat death just as she beat so many other career setbacks. In the 12 years since she died, she has been the subject of five books, two of which, mine and another, were full biographies. Her plays continue to be performed, and they are performed more frequently than the works of male playwrights like Maxwell Anderson, Robert Sherwood and Clifford Odets—all of whom, in their day, were considered her betters. Her work will be back in New York this spring with a new Lincoln Center Theater production of *The Little Foxes* starring Stockard Channing as Regina."[52]

He continued, "One way was to hobnob with others equally well known, to remain a player on Mount Olympus—in her case Martha's Vineyard in summers and Manhattan in winters. In both places she socialized energetically with friends, most of whom had recognizable, and more current, names."

Just as Lillian Hellman was both brash and bold, Dionis Riggs was quiet and reserved. Lillian would not hesitate to castigate or humiliate if she felt she was justified. Dionis Riggs was polite and respectful. Two very different women inhabited the Vineyard during this era.

Chapter 6
Dionis Coffin Riggs (1898–1997): Poet, Author, Columnist

West Tisbury

The obituary in the *Baltimore Sun* eulogized the life of Dionis Coffin Riggs with the words that she "listened to seafaring tales as a child and told them as an old woman."[53] Her heritage was integral to the person she was, yet she added immeasurably to her community.

Dionis Coffin was the granddaughter and great-granddaughter of whaling captains. She was born in Edgartown in 1898 and, throughout her long life, treasured her storied ancestry, which she described in her 1940 book, *From Off Island*.

The youngest of four daughters, Dionis grew up with doting sisters and supportive grandparents. Her mother was Mary Wilder Cleaveland, named for the ship on which her grandparents first met.

Henry Cleaveland, Dionis's great-grandfather, was captain of the *Niantic*, a China trade vessel that later became a whaling ship. His three sons, James, Daniel and Sylvanus, were crew on board the ship as he sailed the Pacific in the 1840s. When the ship reached Panama, Captain Cleaveland believed he could make more money using the *Niantic* to transport miners to the California gold fields; he converted the ship from whales to males and made a handsome profit for the ship's owner. The *Niantic* was sold in 1849 and used for storage and later a hotel on San Francisco Bay. (A painting of the *Niantic* was donated to the San Francisco Maritime Museum by Dionis's three daughters, Alvida, Ann and Cynthia.)

An ethereal image of a young Dionis Coffin Riggs.
Courtesy of Cynthia Riggs.

Just a few years later, Henry's son, James Cleaveland, twenty-eight, then captain himself of the *Mary Wilder*, a whaler sailing the Pacific, fell in love with Mary Carlin, sixteen, an Australian teenager aboard another ship. They were married in the Sandwich Islands, now Hawaii, and then returned to West Tisbury, where they stayed with now-retired Captain Henry and his wife, Mary Ann.

James sailed off on his next voyage and left his young bride with his mother. Mary Carlin found life with her mother-in-law challenging. The *New York Times* shared the story: "Indeed, the woman was so unwelcoming to her new daughter-in-law that the young woman [Mary Carlin] talked her husband into taking her along on a five-year voyage. She returned triumphant with two daughters and enough tales to keep her granddaughter, Mrs. Riggs, enthralled for the rest of her life."[54]

The name of the ship was the *Seconet*; the two daughters were Alvida, born in Chile, and Henrietta, born in Peru, each named for friends made in the respective countries where they were born. When the family returned to the Vineyard, Mary Wilder was born, named for the *Mary Wilder*, on which James Cleaveland and Mary Carlin had met.

In an interview with Linsey Lee for *Vineyard Voices* in 1983, Dionis recounted the story of her illustrious forebears: "My grandmother, you know, was from off-Island, Australia, and found herself lonely here when he was off whaling. So, she joined him. Then, when they returned with my

grandfather on a five-year whaling voyage trip, my grandfather bought this house from relatives. So, this house has been in the family for generations."[55] "This house" refers to Cleaveland House, circa 1750, on the Edgartown–West Tisbury Road in West Tisbury.

Mary Wilder, born following the five-year voyage, grew up on the Vineyard. At the annual Agricultural Fair in West Tisbury, she met Thomas Coffin of Edgartown, and they were soon married. (It was said he was marrying beneath his class, wedding a woman from West Tisbury.) Thomas and Mary Wilder had four daughters: Mary Carlin, Hannah Norton, Barbara and, later, Dionis. One of Dionis's first memories, at three years old, was of her father lifting her onto his shoulders to say goodbye; he went off on a business trip and never returned.

Without her husband's income, Mary Wilder Coffin couldn't pay her bills. She entrusted her children to the care of her parents, Captain James and Mary Cleaveland at the Cleaveland House, and moved to Brooklyn, New York, to work as a governess or teacher. Thus, Dionis was essentially raised by her grandparents and her aunt Alvida. She attended school at the Dukes County Academy, now West Tisbury Town Hall. Her mother returned for occasional visits.

"Mrs. Riggs, who was born on Martha's Vineyard, in Edgartown, had its history in her blood and its turn-of-the-century sounds in her ears," wrote the *New York Times* in her obituary.[56] Dionis Riggs lived in the day when the streets of Edgartown were paved with scallop shells, and she recalled hearing horses' hooves and wagon wheels crunching down Main Street.

In the winter in West Tisbury, Dionis recalled ice skating on the Mill Pond and sledding on Parsonage Pond Hill. She preferred Parsonage Pond for skating, as the wind-wrought ripples of the Mill Pond made it difficult.

The ice of the Mill Pond was harvested in the days before indoor refrigeration: "They had a machine that marked it in squares. A horse would drag the machine, so the ice had to be pretty thick. Then they'd take big saws and saw down these marks and then they'd make one row somehow. And push these out onto a ramp in a truck wagon. Then it would be taken to the ice house and stored with hay. The ice house was in back of that house next to the police station on the Mill Pond. That is where you got your ice all summer, from there."[57] Dionis recalled that her family's well was thirty feet deep, with three feet of standing water; their well water made the best tea in town.

At age eight, at Quansoo, Dionis read a poem she had written to her much older sisters, who patronized her efforts. Chastened, she believed you had to be a poet to write poems and didn't write another for twenty years.

———•———

Grown up and visiting her sister in New Jersey in 1922, Dionis met and married Sidney Noyes Riggs. He had been a bugler in the cavalry in the Mexican Border Campaign under General Pershing and then served in the field artillery in World War I. Gassed and wounded in battle, he was awarded two Purple Hearts and a Silver Star with oak leaf cluster. After returning from the war, he worked for Thomas Edison as head of Edison's diamond lab, experimenting with diamonds as styli for phonographs.

When he married Dionis, Sidney left Edison to become a teacher. Dionis and Sidney had three daughters: Alvida Cleaveland Riggs (Jones), Ann Lewis Riggs (Fielder) and Cynthia Riggs. Sidney became principal of a Jersey City school, where he improved educational performance markedly with environmental modifications, such as painting the walls a lighter color and increasing light intensity. Dionis was active in the New Jersey Women's Club and won a prize in 1931 for a poem she had written. With the affirmation of her peers, she began a long and distinguished career as a poet, composing more than one thousand poems over her lifetime.

In the decade of the 1930s, Dionis and Sidney researched the historical background of what proved a bestselling book, *From Off Island*. They traveled to various ports her ancestors had visited, poring over ships' logs and writing the story together.

The Vineyard always held a special spot in her heart, whether Dionis was in New Jersey or traveling throughout the world. Like her forbears, she earned her living off-island in the off-season but treasured summers on the Vineyard, which she always considered home.

In 1954, Dionis and Sidney retired to the Vineyard, where Dionis became active in the garden club and the historical society, was a founding member of Vineyard Conservation Society and served on the West Tisbury conservation and historical commissions. Living at the Cleaveland House in West Tisbury, she ran poetry groups and published a vast number of poems. She served as town correspondent for the *Vineyard Gazette* and later the *Dukes County Intelligencer*, which Sidney founded.

Of her town columns, Julie Wells, editor of the *Gazette*, recalls, "My memory of her was that she was quiet and had a wise look about her. She never tooted her own horn. I have a visual memory of her bringing in her neatly typed column. And, always the first line was, 'The church was full,' or 'the church was not full,' last week. That was important to her. Also, she always wrote a haiku at the top of the column."

Ms. Wells continued, "She was the columnist; you wouldn't know her story. Perhaps that was her New England reserve. She was low key, yet a person of such history. Very active in community affairs." Julia Wells had the feeling Dionis had always worked at the newspaper. "She was a poet in all the ways. Very quiet."

Dionis was a member of the Want to Know Club, a group of esoteric intellectuals. Once a topic was chosen, the group would assign someone to research and report their findings. Dionis submitted a summary of the meeting to the *Gazette*.

Dionis was a well-respected citizen of West Tisbury, advocating issues worthy of serious debate. She was instrumental in gaining support for the Mill Pond to become a town park. Always interested in flowers and plants, she was friends with Polly Hill, who founded the Arboretum. Polly Hill gave Dionis a giant magnolia bud, and Dionis offered a Primula in return. She enticed coastal ecologist Bob Woodruff to become director of the Vineyard Conservation Society, as well as Eldon Mills to be minister of the local Congregational church. Daughter Cynthia says, "She was good about getting up in town meeting. People listened to her."

Cynthia recalls her parents with amazement: "My father was ahead of his time. He pressed his own trousers. My mother was not a great housekeeper, and my father told his critical mother, 'Dionis takes care of the children, I don't worry about the house.'" They had desks, side by side, in the dining room of the Cleaveland House. Dionis worked on her poems; Sidney carved linoleum block prints and used many of them to illustrate her work. It was a team effort that lasted many years. "They were so respectful of each other's creativity." Sidney Riggs passed away in 1975.

Daughter Cynthia returned to the Vineyard in 1988 and spent ten years with her mother. "We got to know each other as women," she says fondly. Mother and daughter loved canoeing, especially on Tisbury Great Pond. "My mother paddled in the bow," recalled Cynthia. "She took ten strokes, then rested for ten." They still ventured into the little coves around the pond six months before Dionis died.

Dionis converted her home to a bed-and-breakfast in 1988, catering to poets and writers. The atmosphere of a writer's sanctuary permeates the building.

She ran poetry and writing groups in the Cleaveland House, a regular living room poetry seminar. One of Cynthia's favorite phrases in her mother's poetry was "pearl and pewter mist." Cynthia Riggs continues Dionis's tradition of hosting writing groups at the Cleaveland House.

Cynthia also retains her mother's spirit in the mystery novels she writes, set on the Vineyard, which feature a nonagenarian detective named Victoria Trumball, who embodies the craft and insight of Dionis.

"There's something about Vineyard women," writes Cynthia on her website. "Vineyard women are very strong. There's a heritage of the women whose husbands went off to sea, and they were left to run the town and do the farming and take care of the house. We've been given a sense of worth throughout the generations, and you don't lose that strength."

Dionis read poetry in public performances; she would read one of her poems and alternate with Mark Lovewell, who sang sea chanteys. That they were fifty years apart in age made it all the better. "They were delightful," recalls Cynthia. "Their gigs got top ratings at Elder Hostel programs. It was a good balance." Mark recalls, "Dionis launched me. She read her poems and I sang sea chanteys. I learned from her to tell stories, and it really caught on. We were quite a duo, me a young guy with two kids and Dionis an older woman."

As the *New York Times* reported on Dionis's talents, "Her clear, simple and affecting poetic observations so delighted newspaper and magazine editors that she eventually published more than 1,000 poems, many in the *Christian Science Monitor* and her

Dionis treasured the beauty she found around her and often captured it in poetry. *Courtesy of Cynthia Riggs.*

Dionis appreciated the bounty of her West Tisbury garden. *Courtesy of Cynthia Riggs.*

hometown newspaper, the *Vineyard Gazette.*[58] Many of her poems appeared in small chap books or poetry booklets; they were gathered and republished shortly after her death in a book entitled *The Collected Poems of Dionis Coffin Riggs.*

Well into her nineties, Dionis still volunteered to read and converse with the "old people" at the local nursing home. As the *New York Times* described her later years, "Mrs. Riggs, who was long active in virtually every civic organization in West Tisbury, especially enjoyed her weekly readings to schoolchildren (they called her 'cool') and at a local nursing home, where she was older than her 'elderly' listeners."

Dionis continued to submit her weekly town column for the *Gazette* right up to her death. In that final column, she noted a neighbor's goat had given birth to triplets. The *New York Times* reported her death: "Dionis Coffin Riggs, a poet, author, newspaper columnist and civic leader died on April 20 at Cleaveland House, her West Tisbury, Mass., house. She was 98 and had conducted her regular living room poetry seminar there less than a week before her death."[59]

"I've lived through a lot of changes on the island," she told Linsey Lee, "but I think life's pretty interesting."[60]

"Grandmother"[61] is typical of the hundreds of poems penned by Dionis Coffin Riggs in the course of her long life:

My grandmother,
woman of far places,
took us to Quansoo
where waves beat against
the shore
and sand brushed rattly
against the maram grass

She took us to Gay Head,
not where the lighthouse
shed its beams, but where
the sandy road led
through the fields
where wild wood lilies
grew red;
to Christiantown
where rough stones
marked the graves
of Indians

to Menemsha
where fishermen's nets
were spread over the bare
brown hills and the smell
of the catch
was in the earth;

to Edgartown
when court was held
and justice ruled;
to Cottage City
to hear the preacher
with Flying Horses
afterwards;

to shop:
the smell of new shoes
the squeak as we left
the store, the feel
of new cloth, the taste
of Mrs. Revel's ice cream,
bananas and crackers
on the way home.

And all the while
she sang to us—
sad Irish songs
of her childhood.

We lived
in the center of an island
with my grandmother.

"Dionis Riggs and Dorothy West were both intellectually in a league of their own, writers and intellectuals who could have worked anywhere, but they chose the *Vineyard Gazette*," editor Julia Wells theorizes. "How remarkable, that these two very intellectual, lettered women would work for the *Gazette*. The Vineyard was their place. The *Gazette* was their forum. Both the *Gazette* and the community were enriched by their contributions."

Chapter 7
Dorothy West (1907—1998): Writer

Oak Bluffs

"M y father was born a slave; he was freed when he was seven."[62] Dorothy West never minced words. She let her emotions pour forth, expounding on her heritage, her family, her story. Her interview with Linsey Lee for *Vineyard Voices* characterized her style, which carried through in her short stories, novels, newspaper columns and interpersonal relations.

Dorothy West was unique.

Her grandmother had been a cook in the big house on a southern plantation. Following the Civil War, Dorothy's father, Christopher West, came north and opened an ice cream parlor in Springfield, Massachusetts. And a fruit stand. He met and married a woman who patronized his ice cream parlor. Rachel, Dorothy's mother, was one of twenty-two children. The couple moved to Boston, where they operated a successful fruit business. Mr. West was known as the Banana King. His business was so profitable that his wife did not have to work, and they could vacation on Martha's Vineyard.

The Wests were supportive of their only child. One time, however, they argued about what Dorothy should be when she grew up. (She was five at the time.) Her father wanted her to go into business, as he had. Her mother thought she should be a pianist. Dorothy recalls telling her parents, "I don't belong to you, I belong to myself." The shocked expression on her parents' faces stayed with Dorothy all her life.

Another story from Dorothy's youth, perhaps apocryphal, refers to her preferred writing environment: "When I was seven," Dorothy explained, "I

asked her (my mother) if I could lock my bedroom door. She answered with the expected, why? I said I wanted to write stories and that you had to be by yourself when you wrote them because you had to think hard to make them come out right."[63] Dorothy knew who she was and what she wanted to be at an early age.

"I always wrote," Dorothy told Linsey Lee. "When I was about fourteen years old, all I wanted to do was write. I think writing is a compulsion. If you want to write you just have to write. You know, when I am the happiest is when I am writing. When I write something good, sometimes I get so happy my eyes fill up with tears."[64]

At times, Dorothy became so involved in her writing that she felt part of her own story and realized she was losing her grip. Then she would have to go for a walk to clear her head. Her involvement in the creative spirit was intense.

At fourteen, Dorothy West entered a short story in a literary contest run by the *Boston Post* and won a prize of $10. She won more prizes. One of her earliest, sharpest short stories, "The Typewriter," won second prize in the literary magazine *The Crisis*. She won $400 as a prize in a *Daily News* contest for a story entitled "Jack in the Pot."

In 1924, Dorothy traveled from Boston to New York, boarding at the Harlem YWCA. She said, "And there were all these black people all around. I had never seen so many black people in my life; it was just wonderful!"[65]

Two years later, at nineteen, she became affiliated with an artistic black movement known as the Harlem Renaissance. Music, art and writing flourished, as did speakeasies, parties and great camaraderie. It proved a critical point in her life: "The Harlem Renaissance can never be repeated. It was an age of innocence, when we who were its hopeful members believed that our poems, our plays, our paintings, our sculptures, indeed any facet of our talents would be recognized and rewarded."[66]

After the heady days of the Harlem Renaissance, she tried acting, landing a role in *Porgy* for a three-month run in London in 1929. Three years later, West was part of a troupe invited to Russia by the Communist Party to make a movie on the treatment of the American Negro entitled *Black and White*. The film was never produced, but the experience of living abroad expanded her view of the world.

Back in the States, in an effort to rekindle the intellectual curiosity of the Harlem Renaissance, Dorothy founded the literary magazine *Challenge* in 1934. It was a noble effort but did not succeed. Another venture, *New Challenge*, with writer Richard Wright, produced a single issue. But Dorothy kept on.

Subsequently, she worked as a welfare investigator and relief worker in New York and later became involved in the Works Progress Administration (WPA) Federal Writers' Project. She contributed short stories to the *New York Daily News* over the years.

"Wherever I was, I did always want to come to the Vineyard and I finally moved here in the 1940s."[67] She was back "where she had vacationed with her family during the summer months since 1908, when she was just one year old."[68] She characterized her return to the Vineyard as "home of my heart."

Once settled on the Vineyard, Dorothy West secured her place on the island for half a century. Living on the Vineyard "would turn out to be so invigorating for West that one could easily argue that study of this island is the best way of understanding who she was."[69] She worked first as a cashier at the Harborside Inn and then was hired as a filing and billing clerk at the *Gazette*, a position that evolved into writing a weekly column. She was a perfect fit for editor Henry Beetle Hough, who was intent on preserving Vineyard traditions yet intrigued by the African American influence.

A dozen black families from Boston vacationed on the Vineyard each summer in the early 1940s. New Yorker Harry T. Burleigh, who preserved Negro spirituals, was so inspired by his Vineyard visit that he raved about it to his many acquaintances, and soon New Yorkers flocked to the friendly atmosphere of the Highlands in Oak Bluffs. Comparisons between Boston and New York blacks caused Dorothy to pick up her pen once more:

> *And then came the black New Yorkers. They had heard of a fair land where equality was a working phrase. They joyously tested it. They behaved like New Yorkers because they were not Bostonians. There is nobody like a Bostonian except a man who is one.*
>
> *The New Yorkers did not talk in low voices. They talked in happy voices. They carried baskets of food to the beach to make the day last. They carried liquor of the best brands. They grouped together in an ever increasing circle because what was the sense of sitting apart. Their women wore diamonds, when the few Bostonians who owned any had left theirs at home. They wore paint and powder when in Boston only a sporting woman bedecked her face in such bold attire. Their dresses were cut low. They wore high heels on sandy roads.*

Dorothy recalled the impetus for her first novel:

> *I was casually talking about my mother and her occasional bouts with extravagance when I was a child. My father had a profitable business, and he was indulgent with my mother, who was young enough to be his daughter, and so for my mother the living was easy. I did not know that conversation would linger in my mind nor that I would spend the coming winter writing a book in a summer house where the pipes froze and broke, where the snowplow did not know there was one house still occupied on that shuttered street, and the plumber said that nothing could be done till spring when the ground relaxed its grip on the frozen outdoor pipes.*

Dorothy faced the drama of winter on the Vineyard. She focused on writing an autobiographical novel. *The Living Is Easy*, with an introduction by Adelaide Cromwell, was published in 1948 and reprinted in 1982.

With the publication of *The Living Is Easy*, Dorothy West had arrived. She was forty and found her niche. "For over half a century after the publication of *The Living Is Easy*, she was as much a staple of the island as the boats that float back and forth and the specialty shops that attract modern tourists."[70]

And Dorothy West kept writing. Over the years, she wrote dozens of short stories. In a collection published in 1995, *The Richer, The Poorer*, she included empathetic tales from her days as a welfare investigator: "Jack in the Pot" and "Mammy." Though she never had children, she related to the younger set, exemplified by "The Penny" and "The Bird Like No Other." Later stories, such as "The Richer, The Poorer" and "Love," dealt with the challenges of aging and learning to adapt. "Love" exemplifies the concept that one must live for the moment.

Joyce Rickson, a relative of Dorothy West, notes she is the star of the story "The Sun Parlor": "That's me and my most vivid memory of the complexity of Dorothy and her relationship with her mother." As Dorothy wrote the story, she described her effort to beautify her sun parlor: "I am not a painter, but I am a perfectionist." Dorothy, in her mid-forties, forbade Sis (Joyce), age eight, to enter the sunroom, fearful she might mar the walls. At the end of the summer, when Sis and her friends left, Dorothy pointedly wrote, "Taking so much life and laughter with them that the ensuing days recovered slowly." As she limited Sis's access to the sunroom, Dorothy realized she placed more priority on a room than a child.

In her attempt to apologize to Sis, Dorothy captured the moment: "I did not know if she yet knew that nothing can be the same once it has been different."

In the short story "Love," about children, Dorothy compared her niece and nephew as they chose to spend or save their allowance: "I did not see how one child could be so wasteful with money while the other led as full a life on so much less." Of the boy riding the Flying Horses, she wrote, "In his whole life, as he phrased it, he had never caught the gold ring." Meanwhile, the young girl saved her pennies. In the end, the girl realized a key element in life: "That was the day she learned that all the money in her jar could not have bought that gift" from her brother. The gift was the gold ring.

Dorothy could coin a phrase. In the title story, "The Richer, The Poorer," two sisters, Lottie and Bess, realize they are getting old. "Don't count the years that are left us. At our time of life, it's the days that count."

And in a final story, "The Bird Like No Other," a little boy ran home after a chat with Aunt Emily. Aunt Emily could have punished him for ranting about problems with his family; instead, she taught him to sit quietly, waiting for something (that would never happen, but he didn't know that). When the little boy went home, Dorothy said, "He was trying to catch up with the kind of man he was going to be. He was rushing toward understanding."

Vineyard Gazette editor Julia Wells recalls the town columns of Dorothy West. "Dorothy West was a fireplug! When Dorothy came into the office, it was like light-bulbs going on. She was so full of energy." Julia felt an instant camaraderie; they related on a deeper level, as writers. "She engaged you with her eyes. She was intensely interested in you and what you had to say. You could confide in her, talk of anything."

Julia continues. "She was an intellectual. My most amazing interview was with her. She'd clap her hand to her forehead, and gems just fell out of her mouth." She was diminutive, tiny. Dorothy referred to *Gazette* staffer Bunny Brown as "Flossy," and Bunny called her "Dot."

"Dorothy would let you in. She was not afraid to share her emotions. Emotions were part of who she was." Julia felt Dorothy was raised with love. She had a private life but was filled with vibrant love.

"With both women [Julia worked with Dionis Riggs and Dorothy West], their columns are timeless. Read their columns and feel the timelessness of them; they are still relevant today. What a privilege to know both of them." They were weekly columnists for a small island newspaper; both were extraordinarily gifted people, unique in their own way.

Julia says, "Dorothy found her place on the Vineyard. She touched the Vineyard with her very being." She added, "Her column could capture the spirit and mood of the moment, the day, the season. She was such a

perfect fit here. She fit in so well with what [Henry Beetle] Hough was doing with the *Gazette*. It was extraordinary, but at the time, it seemed so ordinary. And here she was, an African American, writing about the community. It was a perfect fit. And Della Hardman followed." Julia recognizes, in hindsight, how ideal the situation was for the *Gazette* and for Dorothy, as well as for the Vineyard community.

Dorothy with her partner, Marian Minus, in 1955.
Courtesy of Joyce Rickson.

When she was interviewed in 1983, Dorothy West recognized her comfort level on the Vineyard. "But, as I say, so much has changed. This is where I am happy. The Vineyard is my home."[71]

Over the years, Dorothy used many sources for her columns. On July 18, 1969, she chatted with a reporter from the *Boston Globe* about the surge in black summer tourists on the Vineyard since the 1940s. She observed that the talk "made this writer very aware of the black involvement in the life of the Island." That reminded her of the Cottagers, a group of one hundred African American female homeowners on the Vineyard who developed a forceful fundraising capacity and program to enrich the community of Martha's Vineyard.

Another column, on July 16, 1971, referred to Cottager's Corner, the former town hall, where the Cottagers encouraged community programs. Dorothy mentioned Carrie Tankard, who had arranged parties for teens over the past winter. "All of the groups at the center are integrated, there being no other way for a society to be viable."

Of the original Cottagers, Dorothy wrote many a column about the group. In one from July 21, 1972, she said, "They were small in number and stout in spirit. They raised money for charitable causes, kept the group together through summers of shifting interests, and began a steady expansion toward community involvement." The Cottagers are still a viable group to this day.

Politics, too, was a subject of discourse. Dorothy West had occasion to meet Andrew Young, a Georgia congressman instrumental in urging Jimmy Carter to run for president in 1976. It was Young's first visit to the Vineyard, for a family wedding. Dorothy noted that a key element to Young's support for Carter was that in the 1950s Jimmy Carter had voted to integrate southern churches.

One column, devoted to the vagaries of politics, reported on a neighbor, Helen Scarborough, who knew Julie and David Eisenhower from her life in Amherst. She told Dorothy that when David and Julie were dating, he would hitchhike to see her, but his grandfather, the president, objected and thus bought David his first car.

Referring to the extended family of Shearer Cottage, Dorothy congratulated Doris Pope Jackson on the birth of her fourth grandchild, Jessica, who "is as lovely as a budding flower, perfect in face and feature. She now joins the fifth generation of Shearers and Popes who have summered here, a strong and flourishing clan."

A recurring theme in Dorothy's column was the theatrical work of Liz White, who produced a live version of *Othello* at Twin Cottage, her magnificent Highlands home. That venture led to an investment in time and

Dorothy West at her home in the Highlands. This image was in the *Vineyard Gazette* on July 29, 1983. *Photograph by Alison Shaw.*

money to film *Othello*. Dorothy mentioned that the film would be shown at the Katharine Cornell Theatre. (It was shown again in 2012.)

Many of Dorothy West's columns referenced the natural beauty of her surroundings, from birds on her feeder to dogs in their local haunts. She reveled in what the editor calls "the vibrancy of island life and the richness of Vineyard tradition, commenting in one entry that 'this island is a microcosm of what the rest of America should be like.'" Dorothy appreciated the lack of billboards, chain stores, parking meters and fast-food restaurants. "The pace of life is slow, people are still largely friendly; it is idyllic in the sense that one can easily forget that beyond its shores looms a hectic world."

Joyce Dresser recalls it was a common occurrence for Dorothy to call up a resident of Oak Bluffs. She would ask about any trips or parties or visits. Then she would turn a mundane event into a big adventure in her column.

At times, the column included a friend's personal experience. On June 24, 1983, she wrote that Olive Tomlinson and friends headed in search of the perfect clam chowder. "Of all the chowders their stomachs had encompassed on the Island and elsewhere, the chowder in the Aquinnah shop was given their unanimous vote as second to none."

Continuing a story about Olive, Dorothy recounted the tale of two reading teachers, Olive in New York and Betsy Medowski in Oak Bluffs, who encouraged their students to become pen pals. As the friendships blossomed, the Oak Bluffs children bragged about jumping off Big Bridge. "The Brooklyn children related to the Brooklyn Bridge, and they gave the Vineyard children very high marks for jumping off towering bridges with such awesome ease."

Dorothy deftly included her own accomplishments as well. She wrote of her speaking engagement in Harlem at the opening of "Women of Courage," a photography exhibit of the Black Women Oral History Project of Radcliffe College.

Of the Vineyard, she wrote, "I have lived in various places, but the Island is my yearning place. All my life, wherever I have been abroad, New York, Boston, anywhere, whenever I yearned for home, I yearned for the Island. Long before I lived here year-round, in my childhood, in the years of my exuberant youth, I knew the Island was the home of my heart."

Dorothy shared an anecdote on herself on November 8, 1985. Several readers assumed that Dorothy was the D.A.W. whose poignant poems appeared in the *Gazette* from time to time. She confessed she was not that poet but confided that "I, too, am an admirer of those who brighten a fellow being's day instead of burdening it." (The poet was Dan Waters, former West Tisbury poet laureate.)

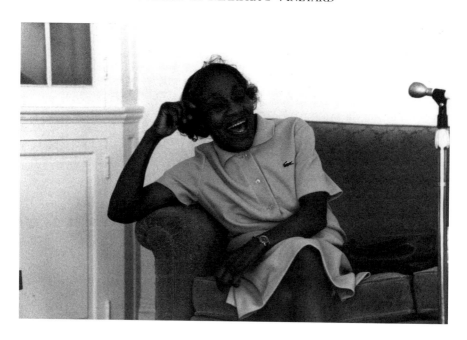

Dorothy was interviewed for *Vineyard Voices* in 1983. *Courtesy of the Martha's Vineyard Museum.*

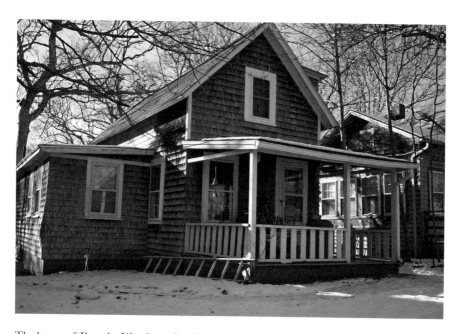

The house of Dorothy West is on the African American Trail. This is where Jackie Kennedy worked with Dorothy on *The Wedding. Photograph by Joyce Dresser.*

The weekly column in the *Gazette* proved the springboard to her second book. Former first lady Jacqueline Kennedy Onassis enjoyed her column, contacted her and, as an editor for Doubleday, convinced Dorothy to resurrect an old manuscript. The two women undertook an aggressive editing exercise.

The story goes that Jackie drove down from Gay Head to meet with Dorothy in the Highlands. Jackie stood in the doorway, surveying a room where every couch, chair, table and bookcase was piled high with books and papers. "Where shall we work?" asked the former first lady. "Why, right here," said Dorothy, and the two sat on the floor and pored over the manuscript.

The publication that resulted, in 1995, was *The Wedding*, set in the 1950s, in Oak Bluffs. Dorothy dedicated the work "to the memory of my editor, Jacqueline Kennedy Onassis. Though there was never such a mismatched pair in appearance, we were perfect partners." Jackie had passed away in 1994, and Dorothy soon followed in 1997, but their time together was priceless. Oprah Winfrey produced a miniseries of *The Wedding* in 1998, which brought further prominence to the works of Dorothy West.

In a book on Dorothy West's newspaper columns, the authors James Saunders and Renae Shackelford concluded, "West, as was the case with quite a few of the other Renaissance writers, faded from the New York scene, but found contentment at the place of her childhood reveries. She became something of a fixture on the island."[72] As she told Linsey Lee for *Vineyard Voices*, "I write for the *Gazette*, you know, my Oak Bluffs column; I do my own writing. This is where I can write."[73] She certainly did do her own writing and fit beautifully into the Vineyard scene.

The same year Dorothy West was born, 1907, Polly Hill was also born. Dorothy had a unique way with words; Polly developed a unique way with plants. Both were obsessively absorbed in their chosen fields. Each loved the Vineyard and treated their adopted home with adulation and respect.

Chapter 8
Polly Hill (1907–2007): Horticulturist

West Tisbury

Anna Alley reported on the opening of the Polly Hill Arboretum in her West Tisbury column in the *Vineyard Gazette*: "There are many fine gardeners and horticulturists in West Tisbury, but the acknowledged queen of this pursuit is Polly Hill, who grew 1700 different species from seed, many of which most would never think able to survive on the Vineyard."[74]

The town columnist went on to describe the hundreds of visitors at the opening who poured into the new visitor center, "which is a lovely accompaniment to Polly's gardens." Anna wrote that "Polly looked tired but happy by mid-afternoon, as she sat in her golf cart next to Steven Spongberg, executive director of the Arboretum." A ceremonial seed planting took place in the afternoon, before spring showers thinned the crowd. Thus marked the public opening of the Polly Hill Arboretum on June 28, 1998.

Born in 1907 in Pennsylvania, the fourth of six children, Mary Louise Butcher, known affectionately as Polly, traced her curiosity about plants back to her parents. She recalled that her mother enjoyed the experience of planting shrubs and bushes but then neglected them. Polly felt more could

and should be done. Her father bought property where chestnut trees had been felled by a blight; he spent months cutting the wood into firewood. These early memories spawned Polly's interest in plants.

While she was a student in college (Vassar, 1928) studying music, her parents purchased a farm in West Tisbury, as a summer getaway site. On the State Road property was a dilapidated building that had once served as a tavern, Barnard Luce's Inn. "In its heyday it served passing travelers a glass of beer or whiskey through an open window."[75] (This building, known as the Homestead, now functions as the administrative offices for the Arboretum.) The family savored summers in the rustic environs of their Barnard's Inn Farm.

After college, Polly taught English and physical education in Tokyo for a year. Back in the States, she met and married a chemist, Julian Hill, who worked at DuPont. He was on the team that developed nylon. They were married on July 23, 1932 and raised three children—Louisa, Joseph and Jefferson—in Wilmington, Delaware. Julian later developed polio and was challenged in getting around—hence the use of the golf cart at the Arboretum. Over their sixty-five-year marriage, Polly and Julian learned to compromise on where to spend their time, whether at the North Lab in West Tisbury for Polly or the South Lab in Delaware for Julian.

In 1954, Polly traveled to Asia. In Tokyo, she met horticulturist Dr. Rokujo over a discussion of a rare fern, a psilotum. Polly and he bonded, and she grew intrigued by horticulture.

Upon her mother's death in 1957, Polly and Julian inherited the West Tisbury property. Now Polly could realize her horticultural interests right on Martha's Vineyard. By 1958, Polly had constructed a small nursery on the property and planted seeds from Dr. Rokujo. Over the years, she shared many seeds and much inspiration with the Japanese horticulturist.

"Polly loved to grow plants from seed," recalled Nancy Weaver, volunteer coordinator and plant recorder. "It was cheaper, and she was quite frugal, which is considered sustainable today. She would trade seeds. [Indeed, members of PHA can request free seeds from a given plant.] As Polly said, plant people share; antiques people don't share."

As the seedlings flourished, Polly transplanted them from the nursery to sites along the varied stone walls that line the property, by the old farm buildings, and out in the open fields and meadows. Religiously she maintained detailed records of what, when and where she planted new seeds, seedlings and plants.

Later, Polly designed a protected nursery area, dubbed Polly's Playpen by the patient Julian, to plant her seeds and nurture them prior to transplanting them into the wild. Nancy Weaver recalled, "I first came to Polly Hill for a

Vineyard Conservation Service Fundraiser. Polly said, 'Come back any time. Don't call, just come.' So I did. I couldn't find Polly so I asked Julian if I could just look around. He said, 'That's all the place is good for.'" Nevertheless, he was very supportive of Polly's avocation.

From the beginning, Polly Hill kept meticulous records of each seed she planted, when it germinated and what she did with it. Her recording system set the tone for a half century of scientific record keeping of her horticultural efforts. She supplemented her earlier studies of botany and horticulture at the University of Maryland by auditing courses at the University of Delaware.

Polly recognized the unique opportunity the acres of open land afforded her. In an interview with Linsey Lee in 1995, she recalled, "My good fortune is to have had this land." She went on, "I look at this land because I'm interested in helping plants. And how it fits with the land and how it fits with the walls and how it fits with the buildings. If you get a feeling of calm, or unifying sense out of it, yes! You try to make it look right."[76] And she certainly made it look right.

As an educator, Polly Hill learned to elicit the very best from people. Whether a horticultural gathering or a rare plant group of the Garden Club of America, she would engage them. She could intrigue a two-year-old with a bright bloom or interest a senior citizen in a flowering magnolia.

Nancy Weaver, who first volunteered at the Arboretum in 1997, recalled, "She'd let you ride in her cart, provided you talked about plants. If you talked about something else, like a wedding or a news event, she'd tell you to get out of the cart. Polly was very focused." One time, Nancy suggested they visit the Agricultural Fair to check out the plants. "'No,' said Polly, 'I am working here.' She always had time for the Arboretum, but not much else." Still, visitors always considered it a pleasure to meet Polly.

She certainly made the Arboretum look and feel right. "Polly Hill has created the finest private arboretum in the country." Thus begins a biography of this dedicated gardener, scientific horticulturist and clever botanist. It continues, "Out in the flat farmland of West Tisbury, in the center of the island of Martha's Vineyard, the arboretum consists of twenty meticulously managed acres of trees and plants, many of them rare and exotic. They are surrounded by open meadows and woodlands and countless stone walls. Everywhere one looks are trees of all kinds and shapes and heights and colors. It is a living museum of trees."[77]

Polly Hill often spoke of the value of views and walls: "I believe in vistas. I try to plan and plant so that a visitor can have long views between rows

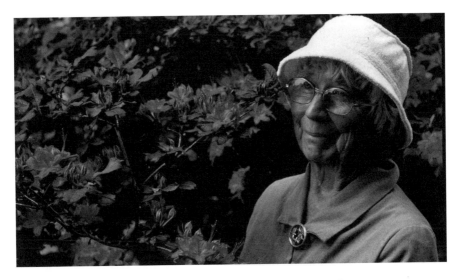

Polly among her blooming azaleas. *Courtesy of the Polly Hill Arboretum, Inc.*

of trees or plants. And one must be aware of the stone walls, our basic design."[78] The Arboretum was "her gift to the Island."

Record keeping was integral to her scientific attitude. As Dennis Hevesi of the *New York Times* wrote in her obituary, "Mrs. Hill was known in the field for her detailed record-keeping, tracing the viability of every seed variety she planted. She maintained a complete 'dead file,' as she called it, as well as daily, weekly and monthly descriptions of those specimens that survived. One of her rare plants, a rhododendron grown from a wild seed, was nurtured for 29 years before it bloomed."[79]

She conducted genetic recordings of her plants, all reported on index cards of information. Her meticulous record keeping proved to be a scientific view of plants; she felt if you could do it once, then repeat it and replant the plant, you were doing it right. Without data, it wasn't science, in Polly's mind. She typed records of each plant. After the name of the plant, she added where it came from, when and where it was planted and how it grew, all in neat, penciled notes. Now all that data is computerized, but the cards are still in use. In the off-season, back in Delaware, Polly Hill became involved in computerizing plant data.

Dionis Coffin Riggs once gave Polly Hill a Primula. It was planted near the visitors' center. On the small index card, the data is recorded: "This Primula was a division, rather than a seed, and the transfer occurred in 1973." In return, Polly gave her one of her prize magnolia buds. (Today,

Dionis's granddaughter, also Dionis, works on the grounds crew at the Arboretum.)

Polly's life centered on plants. Karin Stanley, Education and Outreach administrator of the Arboretum, recalls, "She was very focused on plants, all the time. At one point, my father-in-law's property in Oxford, Maryland, had the original Nelly Stevens holly, a certain cultivated holly named after Nelly Stevens, who was in this house. And the Holly Society put a plaque up outside my father-in-law's house, on the 100th birthday of the Nelly Stevens holly."

Karin continues, "So I shared this with Polly. I thought she'd enjoy it. 'Isn't that nice that your father-in-law has that?' But what she said was, 'How'd she look?' meaning, how did the holly look. She was always very focused on plants. Always that connection with plants. She always used to say you can always talk to anybody about plants."

Polly Hill began her work in the fields of West Tisbury at the ripe age of fifty. Over the years, she recognized that the future of her grounds would not continue unless she could convince one of her children to run the arboretum or manage to put the land into a trust that would permit it to continue. Her goal was to allow the Arboretum to thrive. "To care and to anticipate are more valuable than to achieve, really."[80]

In 1996, Vineyard Conservation director Brendan O'Neill introduced Polly Hill to David H. Smith, who had developed a vaccine for spinal meningitis. Now, Smith devoted his energies toward philanthropy for conservation issues. He respected Polly Hill for her scientific records, as she catalogued her plantings and recorded each item she inserted into the soil. He considered her not only a gardener but also a scientist of plants.

Following his effort to secure the Moshup Trail land in Gay Head, Smith turned his attention to Polly Hill, to establish the Arboretum as a nonprofit organization that could sustain itself beyond the life of its inimitable founder.

The David H. Smith Foundation, through its eminent vice-president, Matthew Stackpole, prepared a conservation restriction to prohibit development of the land and then developed the land to make it functional, with a new septic system, a hidden parking lot and an innovative visitors'

center with efficient, spacious restrooms. The public grounds were organized into a new entity, Polly Hill, Inc., which funded all the renovations.

Polly Hill, Inc., offered a teaching program for local educators, and many teachers participated. School groups are introduced to the inquiry-based training program. Polly always wanted her Arboretum to be community based. By including local schools in the planning process, that goal has evolved over the years. Most Vineyard schoolchildren have visited and enjoyed their field trips to the Polly Hill Arboretum.

Steven Spongberg, from Boston's Arnold Arboretum, was hired as the first executive director. In 2004, Tim Boland succeeded Spongberg. Boland considers the Arboretum "a garden of ideas, a lot of Polly's ideas and a lot of our ideas...the human element is the focus, connecting plants and people."

The Polly Hill Arboretum website clarifies the purpose of the organization: "The Polly Hill Arboretum, Inc., was created to preserve Polly's botanical and horticultural legacy, to maintain the property, and continue Polly's ideals of plant research, education, and conservation." Education is a primary focus of the Arboretum, hence the involvement of school groups.

The Arboretum's website describes its progenitor: "Polly's optimism, intelligent curiosity, and perseverance paved the way for her success. She became known in the horticulture world for her experimental approach and her record-keeping that detailed every seed she grew."

What made Polly happiest was "growing plants and sharing her arboretum." She inspired gardeners and those "seeking the determination to change their life at any age. Polly always said, 'Fifty is a great age to try something new.' Now fifty years later her 'experiment' has become the Polly Hill Arboretum." The site concludes that Polly, "until 100 years of age, remained interested and active in the Arboretum's plans. That's inspirational by anyone's measure."

In the *New York Times* obituary, Dennis Hevesi wrote, "Polly Hill, a horticulturist who stretched the boundaries of plant hardiness by gathering seeds from around the world, especially those of trees and shrubs that thrive in warmer climates, and studying which would sprout and then endure New England winters, died on Wednesday at her home in Hockessin, Del. She was 100."[81]

Today, Polly Hill Arboretum consists of seventy-two acres of land, twenty-five of which are cultivated, and the remaining land is made up of wild and dense woods and untamed meadows. The popularity of the Arboretum arises specifically from its national Stewartia collection, camellias, clematis, crabapples and, especially, its "North Tisbury azaleas and marvelous

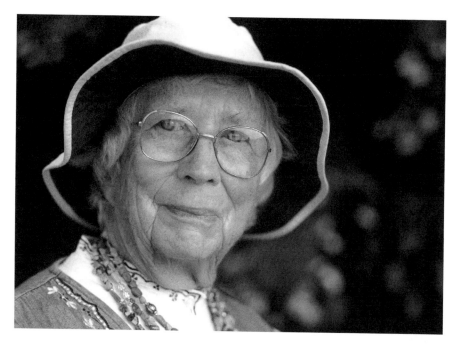

Polly Hill at the Arboretum, 1997. *Photograph by Alison Shaw.*

magnolias." Today, the grounds are mapped out on a computer to note where each item is.

The goal of Polly Hill Arboretum is to gather more "wild collected" plants.

On the grounds, trained volunteers take visitors on tours of the surrounding area. Another group includes visitors' center volunteers. Once the Arboretum was officially opened to the public, Polly would often check up on the volunteers who worked at the visitors' center to ensure the operation ran smoothly.

"Volunteers consider it their garden," according to Nancy Weaver. Polly Hill instilled that sense of proprietary ownership in her loyal followers. She referred to one of her most popular docents, Jeremiah McCarthy, as "the one who's always here." In her later years, she knew the person if not the name. Today, the organization includes over one hundred volunteers.

More than one thousand people are members of the Arboretum. Some fifteen thousand people visit the grounds each year.

She was a very good communicator, says Nancy Weaver. "With me she was direct, but she also could be a proper lady. She knew to ask the right question. She ate her meals on the back porch, and in the later years, when her memory started to go, she'd be sitting with staff, and even though she

forgot a lot, she always remembered what she'd asked someone to do. 'Did you forget to weed the Lydia bed?' she'd ask. She had a selective memory."

For Polly, living in Delaware in the off-season, the fax machine was a necessity. Nancy says, "We'd fax her a question, she'd write her response and fax it right back, keeping the paper as a reminder of what we'd asked. She was ready to retire, but still wanted to be involved. And one of the things she stayed involved in was checking out when plants came into bloom."

On the occasion of a party to celebrate Arboretum volunteers, Polly faxed in her comments: "We can not operate without you. To be needed, that is to be alive." Another time, her words were more poignant: "Grow, let it grow, watch it grow, love from Polly." That said it all.

Polly Hill's legacy lives on. The Polly Hill Arboretum website says it succinctly: "It is a vital public garden, a scientific institution, a community resource, a historic landscape, a conservation corridor, and a beloved Island landmark. At PHA it is our mission to perpetuate Polly's experimental tradition by sharing knowledge of plants through education, research, plant conservation, and exploration. Polly's legacy will continue to nourish the Arboretum she began by planting a seed."

Polly Hill did very well for herself. And for the Vineyard.

A NIGHT IN THE AZALEA GARDEN
For Polly Hill (1907–2007)
By Dan Waters

This gentle country lady's playpen locks
behind you like a solemn wedding vow.
Her pretty daughters in their evening frocks
have formed an aisle there's no escaping now.
The dance begins. Susannah takes your hand,
entangling you with sunset in her smile
until you're grabbed by Gabrielle, whose fanned
and flushing bosom cushions you awhile.
Louisa, frothing at the slightest waltz,
engulfs you in her undulating pink
while pouting Marilee, for all her faults,
spills over your ability to think,
like champagne foam ebullient and bold
this glass of June is far too small to hold.

But out of sight, still hesitant to bloom,
Late Love conceals herself behind the door.
She watches every couple in the room
as if she wishes there were something more
to wish for. Grieved to see her daughter hide
and miss the summer evening that remains,
the country lady takes the girl aside
to tell a family secret: "In your veins
flow centuries of scarlets no one chose
to christen: rooster red on ruffled hem—
Aquinnah clay, and watermelon-rose—
tomato—pomegranate—rhubarb-stem—"
and coaxing color from a brazen past,
Late Love steps out into the light at last.

The country lady looks on from the fence.
She knows her daughters are no swan-necked heirs
to gracious crystal ballroom vases; hence
she wills them barnyard strength in hearty shares.
The band picks up the tempo, partners hurling
partners, petticoats hiked up to here
by hooting, stomping, gingham-twirling
farmgirls letting fiddle music steer;
vermilions trailing summer's longest day,
no chaperones, magenta lipstick tasting
cherry-colored kisses in the hay,
delirious goodbyes, the music wasting…
Overhead the Milky Way still sprawls,
but in the east, the dawn's first petal falls.

Women from off-island moved to the Vineyard and made it their home. Polly Hill loved her West Tisbury fields; Nancy Whiting honored her own property by the Tiasquam Brook. She worked diligently to preserve and protect the beauty of West Tisbury. Both women exhibited strongly held beliefs.

Chapter 9

Nancy Whiting (1925–2007): Activist, Librarian

West Tisbury

In the spring of 1964, Nancy Whiting was one of five white West Tisbury women who brought food and clothing to the black community in Williamston, North Carolina. The intent was to support blacks and participate in a labor boycott and a voter registration drive. Nancy was thirty-nine years old.

Worried about their reception by both blacks and whites, the women were quiet and nervous on their drive down but were warmly welcomed at a church supper, by blacks, when they arrived. The next day, May 1, 1964, they registered blacks to vote. That afternoon, they were part of a demonstration against unfair hiring practices at a Sears Roebuck store. And then the women were arrested and jailed.

It was the police who were nervous about booking five northern white women, all in dresses, respectful and polite. That night, the Vineyard Five called home for bail money; $2,000 was wired, and they were released and drove home the next day.

The citizenry of West Tisbury were proud of their heroines and welcomed them back with a celebratory supper. Later that summer of 1964, when the Civil Rights Bill passed Congress, a gathering at the Tabernacle included a number of prominent civil rights leaders such as Roy Wilkins, Kivi Kaplan and Kingman Brewster. Nancy Whiting said, "It was just when the movement itself was snowballing, too, so it was an exciting time." She was proud to be included in this event.

Nancy Weadock Whiting, in her youth. She wanted to be an announcer for the Detroit Tigers. *Courtesy of Tom Hodgson.*

Years later, in 1993, Linsey Lee interviewed the Vineyard Five: Virginia Mazer, Polly Murphy and Nancy Smith (sisters), Peggy Lilienthal and Nancy Weadock Whiting. Nancy recalled the event: "We knew it was dangerous. We certainly knew that. We knew we might go to jail. And we didn't know if we would come back alive."[82] It was that serious. The women were well versed in what they might encounter. Both Henry Bird and Paul Chapman, who had worked with the Southern Christian Leadership Conference (SCLC) and helped Vineyarders develop a chapter of the National Association for the Advancement of Colored People (NAACP), had warned the women about potential problems.

Nancy picks up the pace of her tale. As the two cars reached Williamston, "we were aware that we were being watched as we came into town. Sort of the vigilante scene. It was scary. Oh they—the white people—hated us."[83] She felt the full power of hatred as the white people realized northern women had come to town: "And that was my moment of truth about hatred, looking into the eyes of hatred. It was terribly shocking."[84]

The opposite feeling occurred at their destination as they met the blacks: "And I remember feeling a kind of warmth and comfort I'd never felt before in my life. It started to become something bigger. It was palpable, like the glow of a fire or a light spreading."[85]

In discussing the Tabernacle celebration later that summer, Nancy realized, "There we were in this wild, larger-than-life kind of thing, the feeling that a person or group of people can have a real influence and effect on the course of events." Still later, she acknowledged the power of the experience, how it proved a crystallizing moment in her life: "Afterwards, I think we felt we'd

been empowered, we'd been strengthened...We pulled it off as a group, to be absolutely true to each other, and that each of us knew independently absolutely not to speak for the whole group."[86]

Thus, it was appropriate for the *Vineyard Gazette* to recognize Nancy's death with the headline: "An Activist in Civil Causes." While Williamston was a pinnacle in her life, Nancy faced many challenges and idealistic goals both before and afterward.

———•———

Nancy Weadock was born in Detroit. Politically, her grandfather, T.A. Weadock, was a powerful figure in the upper Midwest—mayor of Bay City, Michigan, and scion of a family of politicians, lawyers and public citizens. In the 1920s, dozens of male relatives were attorneys, including Nancy's father, George.

A youthful memory, passed on to her son, Tom Hodgson, was that one night at dinner Nancy asked for a little more roast beef. Her mother refused, as children were not supposed to eat much beef. Her grandfather muttered, "Nonsense!" and gave her some. His family had escaped the Irish potato famine in the mid-1800s; he recognized the import of food.

Her mother's family, the Curries, traced their New England ancestry back to Ethan Allen yet migrated to the upper Midwest. In Michigan, her roots included "upper-middle-class shopkeepers and the like," according to son Tom. Nancy adored the Detroit Tigers and wanted to be a baseball announcer.

Her father was an alcoholic whom she saw little of after her parents divorced. Being the only child in a single-parent household was difficult. She and her mother moved frequently. Nancy attended nearly a dozen schools and never graduated high school. She was tomboyish, headstrong and brilliant. She once said, "By the time I was three years old, I knew I was on my own."

As a student, age fourteen, at the Out-of-Door School, a German progressive facility in Sarasota, Florida, she met Sloat Hodgson, a teacher twice her age. Her son says, "She had a truly wonderful time, made several very close friends with whom she stayed involved. It was a very important time in her life."

Later, at Antioch, she studied philosophy but did not matriculate because her father reneged on her tuition. (Years later, she earned a library science

degree at Goddard College.) She was briefly married to Stan Crane. "At Antioch she was one of the few people willing to have a colored roommate," said her son. Family lore claims the roommate may have been Coretta Scott, future wife of Martin Luther King.

Tom Hodgson continues, "There's a long and strong Antioch thread throughout Nancy's life and the Hodgson family. Antioch was very important to her." In college, she gained a strong sense of political justice; it opened her eyes to the world.

During the war years, Nancy worked at Camp Edwall in southern Vermont with Shirley Mayhew. Shirley picks up the tale: "We met when we were fifteen or sixteen at camp as counselors. The first year was 1941, as teenagers. Next year, 1942, the war was on and they couldn't get counselors, so they asked the senior campers to move on as counselors. Nancy was the riding counselor, and I was her assistant. We only had two horses. The camp didn't run in 1943, and we lost touch." But not for long. "I was working in the Edgartown Café, now the Wharf, in 1947, as a waitress, planning to get married in September. In the door walks Nancy Weadock with a friend. And she was planning to get married, too. Then we parted ways again."

In 1947, Nancy and Sloat Hodgson re-met and were married. His grandmother had a summer place in West Falmouth; Nancy and Sloat moved there. Nancy was instrumental in organizing the Woods Hole Child Center. In the late 1940s, she started to vacation on the Vineyard, often renting the Whiting farmhouse at Quenames in Chilmark. Two children were the progeny of the marriage, Thomas Sloat Hodgson and Michele Weadock Hodgson.

"In 1951, I was crossing from Brickman's [Main Street, Vineyard Haven], and Nancy had been renting Quenames," recalls Shirley Mayhew. "We connected. We used to take our four kids, ages two, three, four and five, to the beach."

The marriage between Nancy and Sloat lasted seven years. "Nancy and Sloat were like oil and water," recalls Tom. "They were very different; Nancy was elite in ideas, a people person; a night person and very social. Sloat was elite in politics; didn't like people, arrogant; loved order, a morning person and compulsive." They divorced in 1954.

Sloat continued to live in West Falmouth, while Nancy moved to West Tisbury in 1954, renting various sites in town, once living in The Coop on the Whiting property. (The Coop is a tiny cottage on State Road. Daughter Michele recalls living there at age four and again in her twenties.)

Tom goes on: "She wanted her children to have a father in their lives. Moving to Martha's Vineyard was perfect." Nancy's daughter, Michele,

adds that their mother always made it clear she was not a native. She was twenty-nine when she moved to the Vineyard. Tom says, "She did the best she could as a single mother."

In 1957, Nancy bought ten acres of land along the Tiasquam Brook by Look Pond. The house she had built was a prefab, one of two in the area. During construction, parts of the two houses would occasionally get mixed up and have to be sorted out to make each house whole. (Nancy's granddaughter, Darcy, a nurse practitioner, lives in the house today.)

As a single parent with two children, Nancy managed to pull together a living. She worked at Heathland Farms, a chicken-and-egg operation in the old barracks at the airport. One of Nancy's jobs was to grade eggs. Tom recalls often eating double-yoked or cracked eggs. Nancy kept the books and, on the side, cooked and cleaned houses.

Nancy had an artistic bent. She enjoyed drawing and created small sculptures for her home. And she loved music, especially baroque. One of her son's childhood memories is that there was always music playing. She loved to play the harmonica, and the family enjoyed singing. (Tom Hodgson is a member of the Flying Elbows, a Vineyard fiddler band.)

Tom recalls, "She had strong feelings of citizenship; she got involved in town government." She served on a committee to prevent James Pond from

Nancy with her son Tom and daughter Michele in the late 1950s, after they moved to the Vineyard. *Courtesy of Tom Hodgson.*

becoming a harbor. She was the West Tisbury tax collector from 1962 to 1964 and served as town clerk.

Another thread in Nancy's life was religion, according to her son. She was a lapsed Catholic, "400 years of Irish Catholics." She joined the West Tisbury Congregational Church but withdrew during Eldon Mills's tenure because she felt he was controversial. Tom says, "She really wanted to make a difference; she wanted to get things right with God and to make the world a better place."

Making the world a better place was the incentive for the trip to Williamston in 1964. Daughter Michele recalls, "On my fourteenth birthday my mother went to Williamston. We stayed across the pond with Shirley Mayhew." It is worth noting that some people from Williamston visited the Vineyard after the Vineyard Five went south.

Nancy switched her allegiance to the Grace Episcopal Church in Vineyard Haven and was quite close to Henry Bird, the motivator behind the Williamston effort. She recognized life as a struggle and sought to get it right. Religion was important to her. Over the years, her participation in protests against the Vietnam War and involvement in the peace movement brought some satisfaction that she was doing what she could to change the world. (Her son followed her lead and was a conscientious objector during Vietnam.)

After several years working for the town, Nancy became involved in the founding of the Martha's Vineyard Community Services, under psychiatrist Dr. Milton Mazer. She was his second employee, his secretary, although "she was left-handed, dyslexic, and couldn't spell," smiles her son. She evolved into a research assistant for Mazer's landmark book, *People and Predicaments*, which predicted outcomes based on arrests, accidents and other incidents. One of her constant comments during her tenure at Community Services was: "I am not at liberty to discuss that."

Another thread in Nancy's life was her goal of self-examination, which she pursued through counseling and journaling. "She was a writer," says Tom. "She kept extensive journals for years, boxes of journals. Some of it is stark-raving madness." Although she was not published, she did pursue the art of the written word. She was a great reader.

Following her stint at Community Services, Nancy became the West Tisbury librarian. She used the library to build the community. "One of the very first things she did," said Tom, "was to abolish fines; people hate fines, so that drew people back." The West Tisbury Library was in the small building on Music Street, adjacent to the town hall. With limited space, and few shelves, whenever the library added a book to its collection, another

The prefab house Nancy Whiting had built near Tiasquam Brook in 1957. *Photograph by Joyce Dresser.*

book had to be removed. By lifting the stigma of fines, and no need to renew books, Nancy devised a system whereby patrons kept books at home, on their shelves; when a book was requested, she called the person to bring it back.

During Nancy's tenure, the library became a gathering place for townspeople, a vibrant center of the community. It served as a welcome site for children, with popular children's librarians and school-age interns. As a people person, Nancy made everyone feel at home, turning it into the very valuable asset that it is today. Her legacy lives on as the library expands once more.

In the years following her divorce, Nancy had "an endless stream of disastrous boyfriends," according to her son. She kept searching for love. Stan and Polly Murphy held a dinner party in 1970, and town selectman Everett Davis Whiting, a successful local sheep farmer, was invited. He and Nancy hit it off in a big way. As Tom tells it, "They fell head-over-heels in love." She was "courting with Everett, in an early 1960s Lincoln Continental, with white

Nancy with Tom and granddaughter Darcy. Tom cared for his mother in her last years. *Courtesy of Tom Hodgson.*

leather seats, riding around town, sitting very close to each other." It was a big romance in the small town. Daughter Michele adds, "Their relationship was fun for everybody." She remembers the big white Lincoln, "with two little white heads close together, riding down the road." They were married in 1971, the same year Nancy became the local librarian.

"Nancy had ten years with Everett," says Tom. "They were at a party, dancing, and he died in her arms. The song was 'When the Saints Go Marching In.' The years with Everett were the happiest in her life." Nancy exemplified persistence; she was a romantic who finally found her true love, later in life.

After Everett's death at sixty-six, Nancy worked diligently to settle the Whiting estate, working with the children, saving whatever she could for the family. "As far as I am concerned, the survival of Whiting Farm and what this acreage contributes to the agrarian feel of our community is due in large part to Nancy's contribution. After my father's death in 1981, she worked tirelessly for what she believed to be the best interest of the farm, the Whiting children and the town,"[87] said her stepson Allen Whiting.

Nancy continued as the West Tisbury librarian even when her mother, Martha Sanford, retired, joined her from Florida and then went to work as Chilmark's first off-island librarian.

In her later years, Nancy suffered failing health yet continued her search for the meaning in life. She had always smoked, which led to emphysema. When she regained enough strength, she traveled in search of spiritual salvation, seeking answers at the St. Benedict Center in Madison, Wisconsin, and the Christian community monastery on Iona Island, Scotland. But the lung disease persisted.

She suffered a serious respiratory collapse in 1995 and lingered on life support for weeks. Then she spent months in rehab but managed to return home. Her son Tom served as her caretaker in her waning years.

Daughter Michele adds a plaintive tone to the end of their mother's life. When Nancy said something that didn't make sense, she said, "I have to say it to know it." For her last birthday, in 2007, the question arose of what kind of cake to make. Nancy wanted an angel food cake with sea foam icing, which Michele managed to make. At dinner, Nancy looked up and said, "They didn't make me eat salad."

"I asked her, 'Are you afraid?' She was quiet for a spell, then said, 'I'm not afraid of dying.' That made it easier on me," confides Michele. Nancy died on her father's birthday, November 16. "I believe we do have some choice in the matter," says Michele.

"She was a person of strong opinions, and she had a great deal of character and enormous integrity. In a lot of ways her life was a struggle, but it was a good struggle. She worked at every possible opportunity to contribute to her community and the world," her son recalled for the obituary in the *Vineyard Gazette*. Tom says, "She left the world a much better place."

Shortly before she died, Nancy Whiting was recognized for her role in founding the Vineyard chapter of the NAACP and the drive down to North Carolina with four other West Tisbury women. The African American Trail of Martha's Vineyard placed one plaque outside Nancy's former worksite, the West Tisbury Library, marking the brave effort in the South, and another plaque at St. Andrew's Church, in Edgartown, marking the site of the founding of the NAACP chapter. (Although Nancy was too ill to attend the ceremony, she did see the plaque beforehand.) Nancy Whiting's place in history is ensured.

Another woman who cared deeply for her community, and her culture, was Helen Manning. Like Nancy Whiting, she devoted her life to making the world a better place. Helen worked locally with her Native American and Vineyard students, while Nancy found her role as both a catalyst in the community and a bit player on the national stage.

Chapter 10
Helen Vanderhoop Manning (1919–2008): Educator

Aquinnah

I heard so much about teaching, I never wanted to teach," Helen Manning told an interviewer in 2000.[88] Her mother taught school, and when Helen was growing up, all she heard was how great it was to teach. So she chose something other than teaching.

She worked at the United States Mint and the Library of Congress and later was an assistant dean at Nashville's Fisk University. During the Second World War, Helen worked for the War Labor Board.

And yet, Helen Manning did teach and learned to love it. She taught in the little red one-room schoolhouse in Gay Head (Aquinnah since 1998), where her mother had taught before her. After a dozen years, when that school closed in 1968, she transferred down island to Oak Bluffs and worked as a reading and special needs teacher until her retirement in 1984.

Helen Manning was a teacher, first and foremost. She served her Gay Head community, her place of birth, as a teacher. And she was a proud Wampanoag woman who served her tribe as an educator, historian, mentor, author and tribal elder. Helen was a member of the Martha's Vineyard Commission, a town selectman and a library trustee and served on the Wampanoag Tribal Council for many years. She recorded oral histories of tribal elders. And she published *Moshup's Footsteps*, part autobiography, part tribal tradition, part history book.

When her parents died in the early 1950s, Helen returned to Gay Head to teach at the local school. (The school now serves as the town library but bears the symbols of a school, with two doors, one for girls, the other for boys, and playground equipment still out on the lawn.)[89]

Bettina Washington, one of Helen's students at the Gay Head school, has fond memories. "Helen was my first teacher, so I actually did know her. My birthday is in August, and I turned six. When I went to the one-room schoolhouse, the teacher, Helen Manning, asked what grade I was in. I said, 'Sixth' because I was six years old.

"And so I went to school, and I was the only one in my grade," says Bettina. There were five students in the whole school. "Each of us took a turn doing the pledge of allegiance and leading the school in a song. It was a way of getting us to be unafraid, especially for me, because I was shy.

"I remember learning to read because I had a problem with the word 'you.' I kept trying to figure it out. She kept saying, 'What's this letter?' I said, 'U.' And she said, 'That's it, that's the word.'" The individual attention paid off. "If we weren't getting the lesson, she would take you away from the others, and you would work and work until you got it. She took that time to get you to get it. She was devoted."

"From an educational experience," Bettina says, "we were often taught by our own people. To have someone you know teach you is very important. At that time I don't know if I had the idea that being Indian was necessarily being any different. It was more like I wasn't limited. I never heard anybody say that you couldn't be someone."

Bettina's memories of first grade resurface: "Field trips were not off-island, but I remember going to all the lighthouses.

"And we had our playground right out there, and a pond right out there, and we'd get salamanders and bring them in and watch tadpoles grow into frogs and let them go in the pond." Bettina's memories pour forth: "For school trips we'd jump in the station wagon, and away we'd go. We were learning about culture; it wasn't a separation, it was part of our education.

"I remember we were on TV, too." Bettina goes on, "It was a local station because we were a one-room schoolhouse. We were an oddity. It was something in the news.

"It may be a Gay Head thing, or a small community thing. She was Miss Vanderhoop, not Mrs. Manning; and that was her maiden name." Bettina pauses, recalling that long-ago time: "When they closed the school they

Helen Manning, second from left, among Oak Bluffs schoolteachers. Helen enjoyed the camaraderie in teaching. *Photograph by Joyce Dresser.*

gave us a dictionary, a ruler and a chair. She signed it [the dictionary] 'Miss Vanderhoop.'" She impressed her students as being well dressed and stylish.

"She was a gifted teacher. She taught me my love of learning." Bettina believes Helen Manning (and Gladys Widdiss, too) were "probably the most influential people in my life outside of my parents."

Teaching was how Helen secured her reputation. As a Wampanoag, her heritage was crucial in her teaching. Her obituary in the *Vineyard Gazette* described her teaching style: "Helen incorporated Wampanoag history into the curriculum, instilling great pride in her students as they became educated about their heritage."

Helen Edith Vanderhoop Manning Murray was born in Gay Head in 1919 and summered there in her youth. Her winters were spent in Washington, D.C., with her grandmother. She graduated from Paul Dunbar High School,

in 1936, and remained life-long friends with classmates Dr. Adelaide Cromwell and her cousin, Senator Edward Brooke. Helen's mother was Evelyn Moss, an African American from Washington, D.C.

With her mother of African American descent, Helen faced prejudice. An interview with Joyce Dresser, conducted in 2000, noted that Helen was aware of racism. She said, "I haven't felt any problem with it, but a lot of people have. I knew limitations of growing up in a black community, separated in school. Black society versus white society. Better qualified to teach in a black school because the whites had better jobs. Never upset me."

The steps are all that remain of the Not-A-Way Restaurant in Gay Head. *Photograph by Joyce Dresser.*

Helen's father was Arthur Vanderhoop, a Native American, who operated the Vanderhoop Restaurant (which burned) and then the Not-A-Way Restaurant, both right on the circle at Gay Head. Business depended on a successful summer season and then closed on Labor Day.

The Not-A-Way was across from the lighthouse (all that remains are steps down from the road). It was a three-room inn and restaurant, with a large porch. In the summer, Helen worked there with her parents. When the order cart arrived carrying supplies, Helen checked off the meats, vegetables, fruit and blocks of ice. Her mother oversaw the kitchen, ensuring that customers were well fed. The dining room faced the ocean and had a long table laden with lobsters for friends and family to eat standing up. "And big crowds would come every evening to have dinner," Helen recalled.[90] With no running water, they hauled drinking water from Cook's Spring. The family

kept a cow, a pig and chickens. There were two outhouses—one for men, one for women.

And there was no electricity. "My father generated his own electricity, one of the first in Gay Head," Helen recalled. "He had rigged up a Delco system—he had many, many batteries. We had to really be conservative with electricity because those batteries were only good for so long."[91] They read the newspaper and Sears Roebuck catalogue at night by the light of a kerosene lamp.

Helen retained fond memories of growing up in Gay Head. Beach parties were popular, with a fire down on the shore in Lobsterville. The interview for *Vineyard Voices* continues, "The post office was at Leonard Vanderhoop's house. And that was really a social gathering because everybody came up and it was like being at the steamboat wharf—you're talking back and forth to people. Another gathering place was the Baptist church across from his house."

———•———

"Historian of Wampanoags" was the headline of the obituary June Manning wrote for her stepmother in the *Vineyard Gazette*. Helen lived and taught the history all around her. In Linsey Lee's *Vineyard Voices*, Helen was quoted on what Gay Head meant to her: "I feel personally that the Cliff area, where the lighthouse is and where my house is, I feel that that's very sacred territory. It's sort of hard to explain why. It's something I feel within me. That's where I belong. The Cliffs and that area, they've always been the main resource of the Gay Head Wampanoag people. It gave them an income. For years people sold tons of clay for the making of china and stuff." She continued, "Just being a Gay Header was synonymous with being Wampanoag. I knew that we had a special place, a sense of being a Wampanoag."

In the 1960s, Wampanoag culture was revived. Helen Manning commented on the import of keeping tribal history alive: "First of all, the members of the tribe need to know about their heritage and how important they are. And the non-Indians need to know the contributions the Wampanoags have made to the development of Martha's Vineyard."[92] Helen worked as education director for the tribe and shared the historical culture and Indian ways with the youth. "You got to be something, do something," she said, "not just 'be an Indian.'

"To be Wampanoag, in the first place, it's inside you. It's really something that you're very proud of and you want to be. You want everybody to be the

Helen's home lies in the shadow of the lighthouse on Gay Head. She felt the spiritual power of the land along the cliffs. *Photograph by Joyce Dresser.*

best that they can be so that they can be important and stand for something and not just be running their mouths. It's a sense that you can come into a room and you can pick out your relatives. You can just look at them and you know. It's a feeling that they belong to the Wampanoag."[93] Helen Manning proudly defined and defended her Native American heritage.

"When I was a child, it was very different," Helen told Joyce Dresser, "Aquinnah was the Indian town, but it didn't seem like a tribe. You based your Indian-ness on being from Gay Head. Specifically, you didn't have recognition. There were very few white people, but you had a community. There was dancing and singing at powwows."

After federal recognition in 1987, people were much more aware of the Native American culture. Helen reflected with pride and appreciation on the changes she had witnessed over her long life: "For the Wampanoags, life has changed for the better. We have more of a say in our lives. Bigger social unit. Now it is more obvious. Other parts of the Island thought Gay Head was really far away."[94]

While working at Fisk University, Helen met dental student Joseph Murray. They were married in 1946 but divorced following his service in the Korean conflict.

In 1961, she married tribal member James Manning and became stepmother to June, Judith and Jyl Manning. That same year, the Manning family opened a restaurant near the Gay Head Lighthouse, Manning's Snack Bar, which specialized in quahog chowder, lobster sandwiches, fried clams and homemade pies.

Helen shared memories of her marriage: "We were married thirteen years. Jamie was a commercial fisherman, fishing for fluke, sole, any kind of fish. He liked people; I liked people. We had a lot of fun." When she taught in Oak Bluffs, they moved there in the winter, where they had many parties. James Manning died in 1974, and the snack bar soon closed.

In 2002, Helen remarried Joseph Murray, her first husband.

<hr />

Helen Manning published *Moshup's Footsteps* in 2000 with Joanne Eccher. The book describes Wampanoag culture and history. Wampanoags lived by a seasonal schedule—inland in winter, on the coast in summer. Moshup was their legendary ancestor. "We believe we are the children of Moshup," she wrote. He dragged his foot to create Vineyard Sound and then shared his bounty of fish with the Wampanoags.

Through the pages of her book, Helen retold tribal history: "For the Wampanoags, the Aquinnah Cliffs are a sacred site. He'd [Moshup] keep great fires going, to cook the whale; and, to feed the fires, he'd pull up the trees. That's why today they say there is a scarcity of trees in Aquinnah." Squant (Moshup's wife) cared for the cranberry bogs. Cranberry Day marks the end of summer, the time to move inland. Wampum shells are used for adornment. Wampum is sacred and provides a record of events, such as treaties. "Our legends are the stories that allow us to gain a better understanding of our past and explain our history to our children," Helen wrote.

The Wampanoags are a sovereign nation that function with a council government. Helen was supportive of relearning and teaching the native language, today known as the Wampanaak Language Reclamation Project. She appreciated the drum circle and respected the craft of basketry. She wrote of the repatriation of ancestral remains and treasured the memory of her ancestors. (Helen's great-grandfather was William Adrian Vanderhoop of Surname and Netherlands. Her great-grandmother was Beulah Salisbury Vanderhoop.)

Helen enjoyed her travels. She and Jamie traveled extensively, and Helen continued to take trips after his death. Besides England, Spain and Morocco, Helen visited Peru, Venezuela and Hawaii. She cruised in the Caribbean and journeyed to Mexico and Canada. "Even shopping trips with June, Judith or Jyl were extravaganzas," according to stepdaughter June.

And though she may have retired, she often worked at her cousin Berta Welch's shop on the cliffs. She held numerous community offices. In 1974, she received the most votes as a candidate for the fledgling Martha's Vineyard Commission; she served as town selectman. For many years, she was a library trustee and worked diligently for the Aquinnah Cultural Council. Among the many positions she held in the tribe, her key role was that of tribal council director. Helen played a pivotal role in the federal recognition effort. In many ways, she felt tribal recognition was her greatest achievement.

It was Helen's role as an educator that most impressed people. "She was my teacher," bragged Bettina Washington, chatting with a man one day. "She was *my* teacher," the man retorted. That sense of possession, of pride, comes through with so many who were fortunate to have Helen in their lives.

She loved teaching, and the interaction with people in the community was very important to her. "I preferred special ed. I loved everything except spelling. It was so boring. So simple," she recalled in her interview with Joyce Dresser. Helen had fond memories of Oak Bluffs, with great parties and the staff, who gathered daily when the students went home for lunch. Joyce recalls her as a soft-spoken, wise woman: "When you first met her, you knew she held a quiet wisdom."

Bettina Washington recalls that she attended Helen's retirement party: "When we cleaned out the house [after Helen passed away], we found the note I sent at her retirement. I was so touched that she retained it. You realize how important that first teacher is in your learning experience."

In her later years, Helen Manning was easily recognized in her bright candy apple–red Jaguar convertible, cruising the roads of Aquinnah. Electrician Gary Haley once had the chance to test drive the Jaguar. "I had it going sixty-five miles per hour. I confessed to Helen I went that fast, and she said, 'That's nothing. I had it up to eighty-five and didn't feel it moving that

The fire engine red Jaguar convertible was Helen's delight. She thrilled at driving it around. *Courtesy of June Manning.*

fast at all.'" Helen Manning was a woman who loved life and the opportunity it afforded her to appreciate and share with others.

How would Helen Manning like to be remembered, asked Joyce Dresser in her interview: "We've come full circle. Everything was taken away from Native Americans. But it shows they are survivors. Even though it's not popular to be Native American, a lot of people tried to hide the fact they were Native Americans. There were some people who stuck it out for their tribal members. On the East Coast, the feeling is that all Indians have been assimilated into other nationalities. They're still Native Americans. My great-grandfather was here. It all comes down to how much you care."

"All my whole life I wanted to be in Gay Head,"[95] Helen added. She knew she was home when she was in Gay Head.

Helen Manning worshipped her local environment. She treasured her Native American heritage and honored her African American background. All her life, she respected the heritage and traditions of her upbringing.

At the other end of the island, in Oak Bluffs, Betty Alley lived a life full of traditional cooking, religion and ideals. She embodied the heritage of her Portuguese culture, ensuring that customs were passed on to the next generation.

Betty Alley (1912–2009): Heritage Keeper

Oak Bluffs

M y mother was not remarkable," says Kerry Alley as he lounges on his living room couch, a conspicuous ivy plant flowing across the wall behind him, growing right up and into the ceiling. "She was born and brought up here her whole life." Even as he acknowledges his mother's humble roots, he recounts a rather adventurous tale or two.

Betty Alley was the first in her family to go off-island to further her education. At the tender age of seventeen, her father put her on the ferry to catch the train in Woods Hole. Granddaughter Kati Alley says, "She would always tell the story of how her father got her suitcase and gave her $100 for the year, took her to Woods Hole, put her on the train and she left by herself, to Springfield, for the school year. And she said she remembers that." To head off to school alone was a daunting feat. Betty recounted her story many times.

Kerry played an enabling role in a second story, which occurred on the cusp of Betty's fiftieth birthday. "In 1961, I was stationed in Texas, in the air force." Kerry launches into his tale: "Pat [his wife] was teaching at the Air Force Base. My mother and Patsy Costa took the bus to Texas [from Woods Hole]. They arrived in time for dinner. I asked my mother what she wanted to do while she was here in Texas. She said she'd really like to see her older sister, who lived in California. So, without even doing the dishes, we got in the car and drove to California. It took us two days and two nights. We were there a couple of days, then drove back."

He continues: "Patsy was driving when a trooper stopped us for speeding in the desert. My mother was in the backseat, saying the rosary [in Portuguese]. Patsy talked her way out of it." Patsy told the trooper she lived across the pond from President Kennedy's summer home.

Patsy Costa recalls that trip: "Elizabeth, I always called her Elizabeth, was an angel. She was special; the easiest person to travel with." Of the trip, she remembered Kerry was stationed at Wichita Falls, Texas, and they drove to San Luis Obispo, California, in Kerry's old brown Nash. (Mapquest reports the distance is 1,450 miles, and the drive takes over twenty hours.) Patsy and Betty stayed two more days in Texas, with Kerry and Pat, and then returned to the Vineyard by bus. "It was an adventure all around," Kerry says with a smile.

Kerry's wife recalls, "She was very loving. Her kindness, that's what you remember. She gave a lot."

Patsy Costa adds, "You know I worked with her for twenty years in town hall. She always had something nice to say about someone. They don't make them like that any more."

Elizabeth Marie Madeiras, Betty Alley, was born at home in Oak Bluffs in 1912, in an area known as Little Portugal. Both her parents were born in the Azores, on the island of St. George, and immigrated to Martha's Vineyard in their youth. (The Azores is an archipelago of nine volcanic islands in the Atlantic Ocean, nearly one thousand miles west of Portugal. The climate is temperate and the scenery outstanding.)

In an interview with Linsey Lee for *Vineyard Voices*, Betty recalled her youth. She was the second of nine children, six daughters and three sons. As one of the older children, Betty naturally stepped into the role of helping her mother: "When my mother had all her children, she never had any doctors or anything. She had them all at home, you know, and I used to go down to call my grandmother to come up and assist. I always had to run through the fields and say, 'Come to the house. Mother's having another baby!'"[96]

Betty's life embraced traditional Portuguese customs transplanted to the New World. On Christmas Eve, neighbors would go house-to-house singing Christmas carols—in Portuguese—and playing banjos or mandolins. Women danced the chamarita, a popular Portuguese folk dance. At Christmas, she baked Swedish Filbert Brandy Crescents.

Prayer and religion dominated daily routine as a child, Betty recalled. "In my family we never went to bed that we didn't ask my father and mother to bless us before we went upstairs…And we always had to, when we finished eating, we always had to stand by where we sat and say a prayer, and we all had to do that before we could leave the table. Too many of those customs are

Betty Alley met with a Baypath representative. Betty was one of its most senior alumni.
Courtesy of Kati Alley.

gone from everything."[97] Older women in the community were called *tia*, or "aunt," as a sign of respect.

A neighborhood tradition was the annual pig slaughter to provide sufficient food through the winter. The man who actually slaughtered the pigs, Joe Bernard, would hoist the pig up and then dunk the carcass in boiling water. They used almost every part of the pig, including the bladder, which bounced like a rubber ball.

The root cellar was where turnips and potatoes could be kept cool. "And we had a lot of grapes. And my father made wine,"[98] added Betty. It was customary to serve the homemade wine on Sundays and holidays, but just for the family. In her later years, Betty referred to the concoction as "the recipe." It was juice from the berries and brandy, and then she just let it sit. That was the tradition. That was "the recipe." Throughout her long and full life, Betty did her best to maintain tradition.

Another local custom was May baskets, which were hung on doors throughout the month of May, not just on the first. Each basket was carefully decorated with crepe paper and filled with candy or fruit, then surreptitiously hung on a friend's door. The trick was to hang it and then hide and watch them find it. Of course, some people sought a little more excitement. "And my brothers used to be quite the devils. They didn't only put candy in the baskets they did, they'd put in all the stuff that

they'd pick up from the ground or anything like that, you know. Coal and polliwogs and…Just to be devilish."[99]

Betty's grandmother spoke only Portuguese. Betty's father was unable to read or write English, so each evening a daughter would read the newspaper to him. Betty often played music. The others did their homework. "We made our own fun, like I say, but we got along pretty well. You have a big family like that, you have to."[100] The high school senior class of Oak Bluffs in 1929 had nine students, all girls. No boys. Betty graduated and soon sought to further her education and training.

Betty was the first in her family, the first of her generation, to attend school off-island. She matriculated at Baypath Institute, in Springfield, a two-year business school. "That was a big deal," says her son Kerry. "For a woman from the west end of Oak Bluffs to travel that far to go to school was a big deal." During the academic term, Betty boarded with nuns. She graduated from Baypath on February 5, 1932. The motto for the school was *carpe diem*, "seize the day," which Betty did. She returned to Oak Bluffs accomplished in her secretarial skills such as typing, filing and taking notes. It proved the stepping-stone to her career. Kerry says, "She worked for the town and the county extension service."

Two brothers, Antone and Domingo Medeiros, emigrated from the Azores to New Bedford and then settled on the Vineyard in the 1880s. "Family lore has it that the surname 'Alley,' a play on halibut, was derived from a nickname given to Antone when, as a teenager in Cottage City [Oak Bluffs], he peddled fish in the Portuguese community."[101] Later, Antone moved up-island to West Tisbury and became a farmer. Domingo Pachico Medeiros (Alley) remained in Oak Bluffs.

The great-grandson of Domingo is Kerry Alley; the grandson of Antone is John Alley of West Tisbury. Both Kerry and John claim credit for the name Alley, derived from "alleybut" (halibut). That cry was converted to Alley, according to John Alley. (Apparently, Antone thought the name would set him apart from his Portuguese brethren.) The name stuck.

Betty's husband was George Charles (Medeiros) Alley (1910–1974). His father was Antone (Medeiros) Alley, and his grandfather was Domingo (1864–1922), who emigrated from the Azores.

One of the first positions Betty accepted was to serve as secretary for Harry Pearlstein, a Vineyard Haven attorney. She held the job a couple of years and then served as tax collector for the Town of Oak Bluffs. Subsequently, she was hired by the County Extension Service and spent twenty years working as a secretary under Rosalie Powell, providing agricultural assistance to the community. The Extension Office was initially located in a Quonset hut, which later became the Health Department building adjacent to COMSOG on New York Avenue.

Betty's husband, George, was an electrician. He held the Vineyard's RCA television franchise in the 1940s; his sales and service shop was adjacent to their house on Vineyard Avenue. He passed away in 1974.

Betty enjoyed her time in the kitchen, treasuring Portuguese customs. *Courtesy of Kati Alley.*

Betty and George had two sons, Dennis and Kerry. Dennis gained prominence as the renowned fire chief for Oak Bluffs. Kerry worked for decades as a guidance counselor for the Tisbury School. Both men inherited their parents' spirit and incorporated it into their professional and personal lives, contributing to the community.

Religion was very important to Betty. "It was a big deal," says Kerry. "After she retired, she still volunteered at Sunday school or baked refreshments. She kept up the Portuguese foods and customs."

Betty spoke Portuguese but never tried to teach her sons. "It's something I always regret," says Kerry. "You see, her parents, who had come from the Azores, tried to learn English. They only spoke Portuguese around the kids when they wanted to say something they didn't want the kids

to know." Now he wishes he had paid more attention to the Portuguese words his mother often used.

Betty traveled to Florida a couple of times. One of her sisters moved to Seattle, and Betty visited a niece who lived there. An older sister moved to San Luis Obispo in California. That was the sister she visited in 1961.

Hobbies were important to Betty. She knitted afghans. And she made braided rugs, big ones. She took strips of rags and braided them together. When she was elderly and had trouble walking, the family removed the rugs from the floors of her house for safety reasons; unfortunately, none of the rugs are extant.

In the 1970s, Betty's sister Ruth began to hold breakfasts for friends and family on weekend mornings. When Ruth moved to Edgartown, Betty assumed that responsibility in the 1980s. Children and extended family would gather on Sunday mornings and spend time together. The kitchen was open. "It served the purpose of connecting family once a week," says Kerry.

For the Sunday morning breakfasts, known as "Bumma Breakfasts," Kati recalls that "she made fried dough from scratch on Saturday night, and it would rise." There were usually twenty-five people in her tiny house. "If you knew Bumma was making fried dough, you would come." She hosted the breakfasts both weekend days, with muffins, popovers or the popular fried dough. "Grapenut pudding and popovers; she had to have popovers," Kati recalls fondly.

An annual tradition was her Easter Egg Hunt, where she served fried dough and hid Easter eggs in the yard. Kati remembers, "The Easter Egg Hunt was an annual event. It started with my brother. Every year, she carried on the tradition, using little plastic eggs." For the extended family, it was always a memorable experience. In her later years, Kati bundled Betty up and took her outside for the traditional egg hunt. She loved it.

To her grandchildren, Betty was known as "Bumma," and George, her husband, was "Bumpa." When Betty was ninety-three, granddaughter Kati began to take care of her. Betty weighed only eighty-nine pounds. Kati got her weight up ten pounds in the five years she worked with her. "I took care of her to the end," she says proudly. "I promised she would never go into a nursing home. When she couldn't be home alone, I cared for her. We had a blast."

Kati often took Betty to the hairdresser. "My attitude was: you're not dead yet. You still have a lot of living to do." Kati would get Betty into her wheelchair. "We started little walks into town, getting the mail, going to Reliable." As Kati puts it, "After I started to care for her, Bumma found her voice." As the primary caregiver, Kati managed to get Betty to participate in the world around her, as well as just sitting quietly on her porch.

Betty enjoyed her later years. *Courtesy of Kati Alley.*

"I started walking her to the library, getting dog books and cookbooks." Cooking had always been a big part of Betty's life, and under Kati's care, cooking came back to the forefront. Kati was impressed how organized and detailed her grandmother was. All her recipes listed the ingredients. "We find the recipe, and all the ingredients are listed, but the directions are in shorthand. We'll never know." With her secretarial skills, Betty managed to keep the exact directions a secret!

One day, they made pickled pork. "She told me how to do it. Pickled pork, *vinho d alhose.*" Kati recalled that years ago Bumma often would be frying eels on the top of the stove. Unfortunately, they were unable to find any eels to cook.

And of course, there were traditional Portuguese sweets. "We always made cookies. She always had real-butter chocolate chip cookies. Beach plum jelly and liquor. Recipe is like rocket fuel. She actually had a beach plum bush in her front yard." Betty loved grapenut custard; that gave Kati the opportunity to dig out the recipe and go to work.

Betty lived her whole life in the same area, along or near Vineyard Avenue in Oak Bluffs. "We would walk up Vineyard Avenue, and she would say, 'There's my house.'" Kati enjoyed pushing her grandmother around the old neighborhood.

Kerry recalls his mother and aunt visiting each other on Vineyard Avenue, both in wheelchairs. Each was wheeled out on the street and given the opportunity to chat with the other. "My mother was physically fit to the very end," smiles Kerry.

The insular life of Betty Alley was ideal for her practice of her Portuguese heritage. She lived among other Portuguese along Vineyard Avenue in Oak Bluffs. There she maintained her traditions and honored her heritage.

Another woman lived a very different life on Martha's Vineyard. Known nationally as a popular actress, Patricia Neal vacationed in Edgartown for more than twenty years. Her name was synonymous with fine acting, but she endured more personal challenges than many of her peers.

Patricia Neal (1926–2010): Actress

Edgartown

P atricia Neal lived a life filled with amazing triumphs and devastating tragedies. Her personality was such that she handled the low points with as much grace and equanimity as the highlights in her long and rewarding life.

Growing up in Knoxville, Tennessee, Patricia "Patsy" Louise Neal acted in school plays and summer stock. She made her Broadway debut in Lillian Hellman's *Another Part of the Forest*, where she earned a Tony Award. That signal achievement was her stepping-stone to Hollywood, where she acted with Ronald Reagan in the 1949 comedy *John Loves Mary*.

Over the years, she acted with the likes of John Wayne, George Peppard, Kirk Douglas, Richard Thomas, Curt Jergens, Stephen Boyd, Kim Stanley, Margaret Leighton and Anne Bancroft. She starred in Ayn Rand's *The Fountainhead* and the science fiction film *The Day the Earth Stood Still*. Her performance in *Hud*, with Paul Newman, earned her an Oscar for best actress in 1964. Through it all, she managed an equilibrium that prepared her to handle her sorrows.

In the late 1940s, she engaged in an affair with co-star Gary Cooper, who played Howard Roark in *The Fountainhead* and, incidentally, was married. "Of course I fell in love with Gary," she told the *Vineyard Gazette* in 2000. "I mean, one *look* at him…That was the end of my naughtiness, I think." Following the affair, Ms. Neal was at a dinner party in 1951, given by Lillian Hellman, where she met author Roald Dahl. They were married in 1953

and lived together for three decades. He gained renown as the author of *Charlie and the Chocolate Factory*, *James and the Giant Peach* and other children's books. They had five children: Olivia, Tessa, Theo, Ophelia and Lucy.

Patricia endured a great many tragedies. Theo suffered brain injuries when his pram was hit by a taxi as an infant in 1960. Olivia died in 1962 of complications from measles. Patricia herself, at the age of thirty-nine, suffered a devastating stroke in 1965.

Julia Wells wrote a touching obituary for Ms. Neal, which included the following: "She suffered three strokes and was in a coma for weeks. With the help of her husband, children's book author Roald Dahl, she battled back and returned to the screen in 1968 despite the fact that her impaired memory made it difficult to remember dialogue. 'I used to have a grand memory…having a stroke really takes it out of you,' she told the *Gazette* in an earlier interview (2000), adding: 'Oh, I'm all right, you know. I'm so much better than I was. I didn't know one word from the other.' It was classic Patricia Neal—ever able to make light of adversity."

She was rehabilitated and returned to acting in the 1970s, performing with Martin Sheen and Jack Albertson. She served as Mama Walton in the pilot for *The Waltons*. And she made time to found the Patricia Neal Rehabilitation Center in Knoxville, Tennessee, devoted to patients with stroke and spinal cord injury. In her later years, she reveled in her role as a grande dame of the stage and screen. From June through November, she thrived in her South Water Street, Edgartown home, which afforded an idyllic view of Edgartown Harbor.

Patricia Neal recounted her first visit to Martha's Vineyard in 1980: "On that trip I was introduced to Martha's Vineyard for the very first time. I had read about the island in Katharine Cornell's memoirs when I was young and had courted the idea of going there all my life…I fell in love with the island. I knew I wanted to return. It was a special summer for me. I look back on it as the summer my children and I began a new relationship that would continue for the rest of our lives."[102]

Ms. Cornell was also influential in how Ms. Neal became an actress.

"The most gorgeous moment for me was seeing Katharine Cornell in *The Three Sisters*," she wrote in her *Autobiography*, recalling her first trip to New York as a college student studying acting. "I was absolutely shaking after the performance. I knew I had to find a way to meet her. I headed for the stage door and somehow got past the guard. I stepped onto hallowed ground—backstage of a Broadway theatre. I located the star's dressing room and knocked. She answered the door herself!" That event was instrumental in Patricia Neal's pursuit of a career in the theater.

Stephen Shearer described how she came to Edgartown: "Patricia rented Katharine Cornell's house on Martha's Vineyard for the summer of 1980." She wanted to buy her own house on the Vineyard and learned of property for sale in Edgartown, which she bought, sight unseen. "Once owned by the whaling boat captain on whom Herman Melville based his character Captain Ahab in *Moby Dick*, the seventeenth-century, three-story clapboard structure faced the sea, directly across from Chappaquiddick."[103] A close friend named the house Moby Neal.

Patricia recalled Preacher John Schule, of Edgartown's Federated Church, asking her "to give him the three words I felt were most important in my life. I wrote down 'work,' 'integrity' and 'kindness.'" Mr. Schule delivered a sermon based on those three words, which had the effect of "firing him up."[104]

"I was very lucky in the beginning—don't ask me what's happened since," she quipped in a 1981 *Gazette* interview at her Edgartown home with Roald Dahl. They were divorced within two years, after she learned he had an affair with a close acquaintance.

The interview continued: "Ever indomitable, she carried on, becoming a much sought-after speaker at events for the arts and drama, and placing

Patricia Neal at her South Water Street home, for the *Vineyard Gazette*, July 1988. *Photograph by Alison Shaw.*

increasing emphasis on her work to raise money and help people and organizations devoted to recovery from stroke and brain injuries. Among other things she is founder of the Patricia Neal Rehabilitation Center in Knoxville, Tenn."

Roald Dahl requested a divorce in 1982, which left Patricia alone. "I spent the summer on the Vineyard by myself, mostly watching afternoon television," she wrote in her *Autobiography*. Of the divorce, she wrote, "I will not dwell on the divorce here. I will leave that to Roald Dahl, who is much better at horror stories than I am. It is sufficient to say that I lost my shirt to lawyers in America and England."

Patricia agreed to be honorary chairwoman of the Alzheimer's Walk. Here she is with author Tom Dresser. *Courtesy of Thomas Dresser.*

Shearer rewrote her comments: "Patricia spent most of the summer of 1982 at her home on Martha's Vineyard, watching television…And Patricia suspected that many of her friends were beginning to avoid her because she was frequently unbearable to be around."[105] Her offer to have dinner with a devotee who bid at the Possible Dreams auction proved a success in bringing her life back into focus.

Ever a fan of the theater, it did not take Patricia Neal long to locate and participate in the Vineyard Playhouse. Karla Araujo described Ms. Neal: "She was a familiar figure to theater-goers in Vineyard Haven each summer. Increasingly fragile but unflaggingly enthusiastic and approachable, the late, highly acclaimed actress Patricia Neal was a frequent Vineyard Playhouse patron, beaming her approval to both actors and audience."[106]

It was in the mid-1980s when M.J. Bruder Munafo, artistic and executive director of the Vineyard Playhouse, first met Patricia Neal. Their friendship

bloomed for more than twenty years. M.J. respected Ms. Neal: "She was an active honorary board member for years; attended many performances; donated to the theater." She adds, "Ms. Neal had a standing ticket any time, as an Academy Award actress. She came for years and was an active audience member, although she did face physical challenges."

M.J. recalled that "she always went backstage, into the dressing room, after a Playhouse performance and thrilled the actors with her accolades." Patricia was, in M.J.'s words, "pleased to high heaven. It was a thrill for her to be there. She was always very lovely, very gracious and supportive to the actors. She was a great actress, and she appreciated their effort to get up on stage."

At one solemn event, M.J. recalls, "Patricia Neal dedicated a plaque to her daughter, Olivia, who died of measles encephalitis at age seven in 1962. It read, 'For Olivia Twenty Dahl, my first, with love.'" Even as Patricia Neal's career soared, she carried the death of her young daughter in her heart.

Perhaps the highlight of her Vineyard career, on stage, was the evening she shared her *Autobiography* in a performance at the Vineyard Playhouse. "She performed her one-woman show *As I Am* on our stage as part of our Monday Night Special series on August 30, 2009," says M.J. It was quite an event, with the audience totally engulfed by her performance; applause and adulation continued into the night. "The air was electric," she says. "It was packed to the rafters. The audience was enthusiastic. A lot of prominent people were in the audience. And there were endless ovations for her performance."

Another memorable event was held by the Vineyard Playhouse in honor of Ms. Neal. She was presented with a statue, which served as an award, an expression of appreciation. M.J. recalls, "The party was with the Playhouse people and donors. I remember it was very hot, ninety-five degrees and humid. Everyone was melting. But she always looked elegant."

"My last memory of her," adds M.J., was when "I stopped by her home for a quick visit; she was finishing her makeup—mascara and lipstick. This was approximately two or three weeks before her death. She never went anywhere without looking beautiful."

In a moment of self-reflection, Ms. Neal confided to *Martha's Vineyard Magazine* in a 1991 interview, "But I was always a good actress."

The *Vineyard Gazette* covered Ms. Neal's career for decades. In her obituary, it was noted that, shortly before she died, "Ms. Neal had made an appearance at the Possible Dreams auction on August 2, the annual benefit for Martha's Vineyard Community Services."[107] Included was a statement from the family: "She faced her final illness as she had all of the many trials

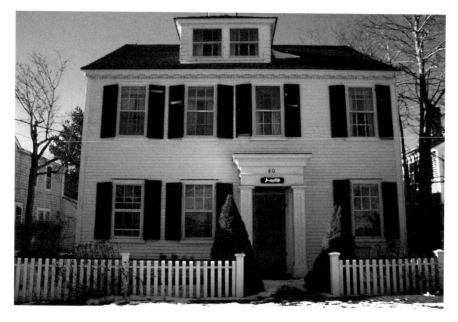

Moby Neal was the name given to Patricia's Edgartown house, once the home of whaling captain Valentine Pease. *Photograph by Joyce Dresser.*

she endured: with indomitable grace, good humor and a great deal of her self-described stubbornness."

In a comment offered to the *Vineyard Gazette* obituary on Ms. Neal, Bob Davis of Falmouth recalled, "From 1980 until 1987, we owned Issokson's Cleaners, and I visited Ms. Neal's home frequently for her dry-cleaning. Many times, I sat at her kitchen table with her to chat about the day's events. She couldn't have been more friendly and down-home. A brave and lovely lady!"[108]

Upon completion of the major renovation at the Vineyard Playhouse, the stage will be dedicated to Patricia Neal. "We hold Patricia Neal and her career in the highest esteem," Ms. Munafo told a reporter. "She was the 'Grande Dame' of the Vineyard and such a friend and supporter of the Playhouse. The dedication of the stage was a sweet decision." Ms. Munafo was so pleased that the four children of Ms. Neal participated in the dedication ceremony.

"It was my idea," Ms. Munafo goes on. "She was my first choice to name the stage." Ms. Neal's children knew the stage would be dedicated to her but failed to tell her before her death. "But I have an inkling," says M.J. "No one knows for sure, but I think she had an inkling."

Daughter Lucy Dahl shared her thoughts with writer Karla Araujo. "Mother loved life on the Vineyard, finding joy in the small-town feel of the community and the way it accepted her,"[109] wrote Ms. Araujo. Lucy's comments continued: "An actress's life is a 'Catch-22.' They feed off recognition but want to be treated like the girl next door. Here, she achieved both and found a happy balance." And "she used to drive by the Katharine Cornell Theatre in Vineyard Haven and make a funny comment about how Katharine has her own theater," she says. "Out of all the awards and recognition she earned, this would be her greatest thrill. Her legacy will remain alive in a place so dear to her."

Sister Ophelia agreed. She, too, was quite pleased that the Playhouse would recognize their mother by naming the stage for her. "The Playhouse featured prominently in her time on the Vineyard," she observes. "She battled through so many difficult times and emerged intact. This naming of the stage is a tribute not just to her talent but to her strength, her talent, her incredible dedication to her craft and to her happiness in bringing people together. It's fitting that the Playhouse is a gathering place, a place where people meet."

Patricia Neal was ever gracious. Always stylish and well dressed, she counted on her appearance to make an impression. Known nationwide, she was as respectful and pleasant with locals as with Hollywood stars.

A woman who purchased her clothes in thrift shops and did not care about her appearance, or the impression she made, was Helen Lamb. She, too, was trained as an actress but made it her life's work to operate a summer camp for handicapped children. Helen did not care what people thought of her, but she did care how people worked with her kids. As direct and blunt as Patricia Neal was reserved and polite, both women dominated their stages.

Chapter 13
Helen Lamb (1915–2011): Camp Director

Vineyard Haven

H elen Lamb earned her nom de plum, Hellcat, by the way she drove. Her son John Lamb recalls a typical story: "Once she was traveling to Woods Hole and speeding, probably late for the ferry. A cop stopped her. Helen said, 'I am the director of the camp and I have to get on this boat.' Her anger was real. She just had the ability to do these things. She convinced the cop to escort her to the ferry, lights flashing." That is every Vineyarder's dream, but only Hellcat could pull it off. The *Boston Globe* reported that "Helen Lamb picked up the nickname Hellcat for her take-no-prisoners approach to driving, but it fit tidily with all aspects of her life."

It was rumored that on occasion Hellcat would drive on the left-hand side of the road, reverting to her English upbringing, much to the horror of fellow drivers (and her passenger!).

———◆———

In 1953, Helen Southworth Lamb founded the Martha's Vineyard Cerebral Palsy Camp, a summer program for disabled children that flourishes today. The reputation of Helen Lamb evolved over the years, just as the camp itself developed, being the first overnight camp for

disabled children in the country. It has always been staffed by volunteers, and camper families pay the same rate today as when the camp opened. Helen's program lives on, her vision still firmly behind the wheel.

In the 1870s, Helen's aunt and uncle came to the Vineyard. Uncle Reuben Phillips ran a butcher shop on Circuit Avenue, and his son, John Phillips, opened Phillips Hardware. Helen was born in England and first came to the United States at the age of four in 1919. She attended school in Oak Bluffs for a while, before she returned to England. That experience laid the groundwork for her lifelong passion for the beauty and opportunity of the Vineyard.

Helen studied acting at the Royal College in Manchester (England) and began her professional life as a stage actress. (Her granddaughter Sarah currently dances with the Royal Ballet in London.) Along the way, she trained as a speech pathologist. On a train near Manchester, she met her future husband, John Lamb, whom she characterized as "a very fine violinist."[110] He taught music at the Royal College. They eloped when she was twenty-one, in 1936. John had her choose between acting and raising children, and Helen opted to be a parent. Three children were born: Gillian Lamb Butchman, Janet and John Jr.

During the war years, Helen worked in a relief program for children injured in the bombing of Britain. After the war, in 1950, John Lamb, fifteen years her senior, died from gases and chemicals used during the war. He left Helen a widow, with three young children and a mission.

"Hellcat was a character," recalls her son, a hint of amazement in his voice. "Kind of fantastic." When her husband died, she took her three little kids and moved across the ocean to New Bedford, to live with her mother and sister. She found a job in a cerebral palsy clinic in Fall River as a speech therapist. "I had trained as an actress, but I also did a lot of course work in speech therapy and got a degree, finally, in speech pathology. And I was always so glad I did that, because I was able to come to this country with a profession, ready to give,"[111] she recalled in a 1999 interview with Linsey Lee.

As a speech therapist working in Fall River, Helen realized that children with cerebral palsy had very few outlets to enjoy the out-of-doors. And the parents of disabled children needed a break from caring for their children. In the summer of 1952, Helen visited her sister, who owned a house on Martha's Vineyard, and hatched the idea of a summer camp for disabled children.

Her son explains she wanted to "start a camp for kids stuck on a third-floor walk-up. She thought having a camp would be great. It hadn't been done. No one had a camp for handicapped kids in the United States. She

Children with cerebral palsy reveled at the camp run by Helen Lamb. *Courtesy of John Lamb.*

kept at it." In her own words, Helen explained her motivation: "I started it [Camp Jabberwocky] for one specific reason at that time: to try to get the children who were in my clinic in Fall River away from their parents for at least one week."[112] She charged fifteen dollars a week.

The first season was in 1953 at the Happy Days cottage in Oak Bluffs. Five handicapped children with cerebral palsy and a high school assistant composed the initial contingent. Helen recalled, "We got through that first summer very well. No one was ill."[113] Each week she brought over three or four kids from New Bedford. Her motto was "Start small and grow."

The next year, the camp relocated to a 4-H Quonset hut on New York Avenue (now COMSOG), with a shower and kitchen facilities. Volunteers constructed small cottages on site. There was no big red bus for the campers at first, as son John recalls: "They had no transport, they walked everywhere, some of the ambulatory campers pushing campers in wheelchairs. Hellcat heard that people said it was a crime for one woman to have so many handicapped children."

The president of her board, Peter Pinney, knew how to handle her: "He said, 'Don't argue with Helen Lamb anymore. She's going to get what she wants anyhow! So just let her have it!'"[114]

And she did. She needed ferry tickets for the campers to reach the Vineyard. As a state agency, the Steamship Authority does not hand out free tickets. Her son John says, "Helen called the guy every day for weeks, sometimes disguising her voice to get through. Eventually, the guy gave in. 'Oh my God, woman. How many tickets do you need?'" Her persistence paid off.

One of Hellcat's favorite stories occurred during the first years of the camp. As son John tells it, "She was at the Flying Horses,

Camp Jabberwocky has a special section on State Beach. Helen enjoyed the trips to the beach. *Courtesy of John Lamb.*

standing and watching the campers and counselors trying their damnedest to catch the rings in all manner of attitudes and positions. A man came up to her and said, 'See these kids? They're from a camp up the hill here. It's run by an old crackpot of a woman. But I guess she's got a good heart.' It was a story she told over and over again and she laughed just as much in her last telling as in her first. I think it was how she actually saw herself, in a way, an old crackpot of a woman, but with a good heart."

In 1964, there was a misunderstanding over who owned the cabins on the 4-H land. "We could have moved the cabins," says John, "but that didn't happen." Instead, the minister of Grace Church gave them five acres (now fifteen) of land on Greenwood Avenue in Vineyard Haven. For a number of years, carpenter Gene Pepper worked on the construction and maintenance of the campers' cottages. He proved a mainstay in the campus of the camp, even building a year-round house for the caretaker.

John Lamb gave the camp its name. While in college in 1965, his roommate gave him the *Annotated Alice*, "and it really got me going." Many Lewis Carroll poems were ironic takeoffs or spoofs on Victorian poems, written to

Helen Lamb at Camp Jabberwocky, in front of the big red bus, for *Martha's Vineyard Magazine*, 2002. *Photograph by Alison Shaw.*

brighten the lives of children but in reality, dull and boring. Other camps for handicapped children had been formed, such as Camp Joy, Camp Freedom and Camp Jolly. "We wanted something unique. I was reading *Alice*, and came up with Camp Jabberwocky, from Lewis Carroll, and all the cabins are named for the nonsense words in the first stanza of that poem." John adds, "The only ones who don't enjoy the names are electricians and plumbers who come to repair items in the cabins."

Helen Lamb was always on the lookout for volunteers and donors. Once she picked up a couple of girls hitchhiking, brought them back to camp and put them to work painting a sign. She had a superb ability to encourage people to do something they initially had no interest in.

Helen staffed the camp solely with volunteers, who worked diligently with the developmentally disabled children. Hellcat brought a sense of purpose to her gift of providing a respite for children otherwise denied access to summer adventures because of physical limitations. Jabberwocky invites up to seventy-five campers each summer under the guidance of more than fifty counselors. There are two sessions, one in July and the other in August.

Jeff Caruthers recalls an incident, nearly forty years ago, when Helen was director and Jeff was in his early years as a counselor:

After a very intense day of working [playing] with the campers, doing chores, having fun and giving 150 percent, counselors replenish their giving energy by playing practical jokes on one another and hanging out after campers' bedtime. I will never forget the time when we [counselors] were doing just that and the practical jokes and our "frolicking" got a bit loud.

The director's cabin, Uffish, where Hellcat slept is near the main cabin. The evening frolicking was near the main cabin, and we soon saw the outside light of Uffish come on. All eyes were directed there, and we saw the silhouette of Helen Lamb, big as her personality. With her booming voice, we heard, "Get quiet and go to bed, right now!" This sound filled our ears, and my body responded.

I hit the dirt. I then crawled on the ground as if I were in the frontline trenches, doing all I could to protect myself from Hellcat's vision and verbal bombshells. On my belly, I crawled from the main cabin to Galumphing, where I slept. Finally inside my protected area, I caught my breath and relaxed in bed and floated off to sleep.

In the morning, fearful of what breakfast would bring from Hellcat, we heard nothing about the previous evening, surprisingly, which was not typical of Helen Lamb!

Helen described her program to Linsey Lee: "We have our glorious play each session that the campers and counselors write and direct and perform. And we go riding and windsurfing and make movies and do pottery and go to the beach and we all have a glorious time. But I think acting has been the greatest training for me all through this: to be able to turn all these life dramas into a humorous situation, if at all possible. And we do."[115]

John returns to his mother's ability to get what she needed:

I was instructed to pick up ice cream and bring it to Chappy. The people on Chappy gave us a picnic. The bus went ahead [on the ferry] with the kids, and I came later, with the ice cream. There was a long line of cars waiting to get on, so I drove to the end of the line. Helen came over and said, "We don't have time for that." She directed the ferry man to hold the cars and tried to get them out of the way.

It wasn't happening fast enough for her, so she started running in circles, getting attention and moving the cars out of the way. When asked why she was running in circles, she said, "Someone has to do it." That was her

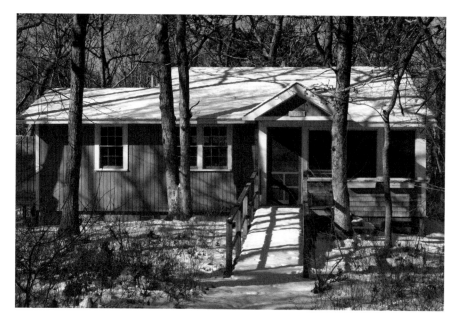

Uffish Cottage was where Helen stayed during her tenure as director of the camp. *Photograph by Joyce Dresser.*

version of herself, she stirred the pot. If you said, "This is the way it's always been done," she would have a fit. Complacency was her enemy.

People recall that Helen was always on the go, full of high energy and motivation.

"When she got an idea, she would do crazy things. She encouraged young boys to do slightly illegal things, playing pranks." John Lamb described an incident that made his mother laugh: "There was a sign on Lawrence Avenue, near where the Landers family lived. We repainted the sign to read Landers Lane. It stayed like that for years until it faded and was replaced with two signs, one that read Lawrence Avenue and another Landers Lane. She was fun-loving. I must have been fifteen then."

She did not have pity for the campers. Helen said, "The kids are here. We have the job to make their lives a little more bearable. We should do it." Throughout her long life, she practiced what she preached; her clothes came from the thrift shop, she rarely dined out and she lived her life as she saw fit. John recalls her as tough but not a saint. "If a camper didn't do what they were told, they were going to get it. They got a lot of good counselors, who kept coming back." For more than thirty years, John Lamb was camp

director. "I'm still involved, as is my family," he says. "My daughters are still counselors." His wife, Kathleen, was the cook for many years.

Using her acting prowess, Helen evolved into her role as the dominating force in the development of Camp Jabberwocky, where she was both feared and respected. All the counselors are volunteers; none is paid. The only people who receive a paycheck are the bookkeeper and caretaker, and the cook is often offered wages. Doctors donate their services. Hellcat was never paid, and she expected others to volunteer as well.

John recalls a conversation with a couple of staff members: "I remember sitting down with a few counselors and asking, 'What would you think if we paid counselors?' One said, 'If you paid us, we'd never work as hard!'" Each counselor does the work for the enjoyment of doing it. And experience. Many colleges now seek applicants who have participated in community services. Often counselors use Jabberwocky as a stepping-stone to become doctors, therapists or social workers.

Tom Dunlop characterized Hellcat in the obituary he wrote for the *Vineyard Gazette*: "The strength of her character—impatient and outspoken, by times full of laughing English fun—was nearly as famous across the Island as the camp itself." He concluded, "Her life was dedicated to helping the disabled live to the fullest measure possible."

Helen Lamb did not exhibit the usual sense of sympathy for her clients. As an atheist, she could not believe a compassionate God would allow his children to suffer or be punished. She believed that was utter nonsense.

Hellcat added a year or so to her age to make herself feel older and more important. She died at 7:30 p.m., on the day before her birthday. Kathleen's brother realized she had been born in England, five hours ahead of the States, so she actually died on her birthday.

Helen wanted her ashes scattered in the ocean along Lambert's Cove Beach. Each year, the extended family, children and grandchildren walk the beach. John Lamb said, "She gave us something so much nicer than going to a cemetery. We get to walk the beach and see her all around us."

Helen Lamb held tradition and custom in disdain. She felt if something had been done one way all the time, there was no reason not to change it. She was outspoken, radical and a character by all accounts.

Doris Pope Jackson was diametrically different from Helen. She was conservative in that she sought to preserve tradition and family life as it had been. She did not want to upset the status quo but chose to thrive within it. Doris did not stand out as flamboyant or radical. She supported her family and the heritage of her past.

Doris Pope Jackson (1915–2012): Innkeeper, Artist

Oak Bluffs

S hearer Cottage was the first inn specifically built to welcome African Americans in Oak Bluffs. It celebrated its centennial in 2012. Doris Pope Jackson was the granddaughter of Charles Shearer, who opened the inn in 1912. Throughout her long life, Doris preserved and improved the standards of Shearer Cottage.

Charles Shearer was born a slave in 1854. After the Civil War, as a student at Hampton Institute in Virginia, he met and married Henrietta, who was part Native American and part African American. Charles taught at Hampton, and both taught in nearby Lynchburg. Later, they moved to Everett, just outside Boston. "He had graduated from Hampton Institute, which was set up to educate former slaves, which he was. And when he came north, he had a college degree so he was a learned man, and he was the head waiter at the Parker House and at Young's Hotel, which was a very good job for a black man."[116]

In 1903, motivated by the Baptist movement, the Shearers purchased property in the Highlands, in Oak Bluffs, on Martha's Vineyard. Henrietta set up a laundry service for white vacationers; she would pick up and deliver linen with her horse and wagon.

When friends came and were denied lodging in town due to racist practices, the Shearers expanded their cottage to let people stay with them. This evolved into Shearer Cottage in 1912, the first inn to cater to the African American vacationing population. Once the cottage was up and running, the horse and buggy ferried guests up from the Highlands Wharf.

Today, Shearer Cottage is still a viable entity, adjacent to the Baptist Tabernacle, which was the center of the African American community in Oak Bluffs. Back in the day, Charles Shearer often brought guests over to the Baptist Tabernacle (which no longer is extant). "And that's why my grandparents started Shearer Cottage, as a lodging house catering to African Americans,"[117] Doris recalled in a 1996 interview.

She continued, speaking of the value of owning property on Martha's Vineyard. "I think that's the way most Islanders feel. I think there's something that's inherent in owning property on this Island, really. It is a love for wherever you stay, your home, your land, where you grew up."[118] Doris Pope Jackson realized the importance of being part of the island community. Shearer Cottage is special, and as a member of the third generation of innkeepers, Doris always treasured that special feeling.

———•———

Charles and Henrietta Shearer founded Shearer Cottage. They had three children. The two daughters, Sadie and Lily, inherited Shearer Cottage, while their son, Charles Jr., was left the family's winter home in Everett. Sadie and Lily ran the cottage, and consequently it was their children who inherited and operated Shearer Cottage.

Lily Shearer met and married Lincoln Pope at Shearer Cottage. They, too, had three children: Elizabeth (Liz) (White), Doris Pope (Jackson) and a younger brother, Lincoln Pope Jr. Unfortunately, Lily died in childbirth in 1920; thus, Sadie ran the inn for many years.

"The family all cooked and helped and cleaned and did everything to hold on. And that's what I do now. I don't cook, but I do clean. Because of the history of the cottage, I still work hard to hold on to my grandparents' legacy,"[119] Doris shared the Shearer heritage in an interview with Linsey Lee. Doris did it all: gardening, painting, cleaning—that was family tradition.

From its establishment in 1912, her parents and grandparents all worked at Shearer Cottage, making it a premier inn for African Americans. Doris's children, grandchildren and great-grandchildren also consider Shearer Cottage a special treasure, to be preserved, protected and promoted. The great-great-grandchildren of today recognize the value of earning money at Shearer Cottage: save, spend and savor.

Doris Jackson as a teenager in Oak Bluffs in the 1920s. *Courtesy of Lee Van Allen.*

Doris's daughter, Lee Van Allen, captures the essence of family pride and the devotion they all feel for Shearer Cottage. "And one of the things my mother always did, and my Aunt Liz [Doris's sister] and my children and my generation as well, the family would work there." She goes on, "They all got paid. They worked as a chambermaid, dishwasher or waiting on tables. My mother's generation all did it, my generation did it and my kids did, and now my grandchildren have done it, taking care of the garden, doing odd jobs, painting, laundry."

Lee continues, recalling stories of Charles Shearer, her great-grandfather: "That's another life. He was a headwaiter [in Boston], but he was also an

innkeeper [on the Vineyard] and a property owner [in Everett] and very much a successful person. He had those two roles; he had to make money so he could live. I think my mom [Doris] always was very proud of what he did, having been born a slave, and what his accomplishments meant to the family."

Doris herself had a special bond with her grandfather Charles. He was "tall and straight and handsome. We spent a lot of time with him. He was articulate—you'd always see him in a starched shirt and tie and a Panama hat, always very proud. He was about six feet two. He was like a prince, and he looked like one."[120]

Lee shares stories about her mother, Doris: "Shearer Cottage, in addition to her family, was every bit as important to her. And her grandfather, whom she dearly loved. She was his favorite. She'd say, 'He'd go downtown and bring back a bag of candy and give it to her to distribute to her cousins. I'd give one to each one of them and take two to myself.'" (Charles Shearer knew but never said a word.)

Doris in high school. She lived in Everett in the off-season and spent her summers in the Highlands of Oak Bluffs. *Courtesy of Lee Van Allen.*

Doris Pope spent her summers on Martha's Vineyard, working at Shearer Cottage. "So we were brought up on the Island."[121] Her Aunt Sadie was a great cook and served their guests three meals a day. Sadie specialized in popular southern cooking.

In the interview with Linsey Lee, Doris recalled, "The guests were very prosperous people. And all of these blacks were very, very well-educated blacks. Artists, judges, lawyers, principals of schools, teachers, congressmen; they all stayed up at Shearer Cottage. So it was packed up there. At times

there were as many as sixty people in the dining room."[122] Each evening, Charles Shearer dined with his guests.

Most guests were well-to-do blacks from New York who dressed for dinner. Lee recounts one memorable evening when Doris was waiting on tables at Shearer, in the days when meals were served. "Guests would come to Shearer for a week or two weeks. They had their meals there. Mother had waited on a doctor from the middle section of the country. He came every year and had a big Cadillac, very wealthy man, very highly respected man. He always demanded to get his dinner first. The way at Shearer Cottage would be at dinnertime they rang the bell. Then everybody came to the dining room. And he always would get there first and get his dinner first."

"One day he was late, and my mother was waiting tables." Doris told the doctor she waits on people who get to the dining room first. He did not like that. "This particular doctor was very indignant because he wanted his dinner. Everybody knew he was indignant. And my Aunt Sadie said, 'Now go give this to doctor so-and-so,' but my mother served the people who got there first. Every time she came back, Aunt Sadie said, 'Give it to the doctor.'"

"And Charles Shearer, who was *the* boss, said, 'She's doing the right thing.' That story reflects who she was, very fair, and also shows he respected her judgment. They had a special bond."

The guest list for Shearer Cottage reads like a who's who of prominent African Americans of the twentieth century: Harry T. Burleigh, Ethel Waters, William Lewis, Judge Herbert Tucker, Reverend Adam Clayton Powell, psychiatrist Dr. Solomon Fuller and his sculptor wife and actor/activist Paul Robeson were all guests. Many felt so welcomed by their stay at Shearer Cottage that they bought property in Oak Bluffs.

Shearer Cottage catered parties, fundraisers and festive activities. It was home to the Cottagers (the philanthropic group of African American women) and the Shearer Summer Theater (Liz White's thespian performers) and the site where many African American couples first met. It was *the* place to be in the African American community on Martha's Vineyard in the mid-twentieth century.

Lincoln Pope, Doris's father, was from Virginia. He met Lily Shearer when he vacationed at the cottage. Lincoln was a Boston businessman who

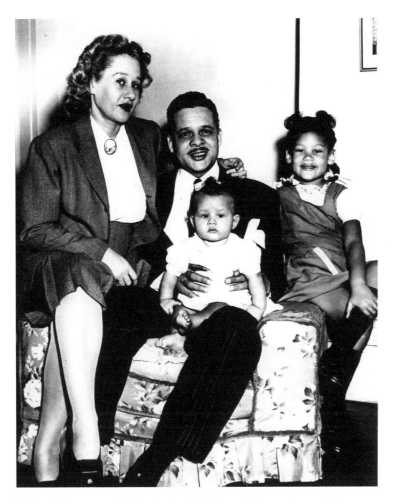

Doris with her young family: husband, Herbert; Gail, age five; and Lee, age one. (Herbert Jr. had not yet been born.) 1932. *Courtesy of Lee Van Allen.*

sponsored a black baseball team. During Prohibition, he owned the Phalanx nightclub, also known as the Black and White Club for its integrated clientele. Lincoln's father, James Pope, graduated from Boston University Law School and served as a Boston city councilor.

When Doris was five years old, in 1920, her mother, Lily, died in childbirth. The trauma of losing her mother stayed with Doris throughout her life. Lily had gone to the hospital to have a baby, and both mother and baby died. Doris recalled that their wake was held in the front room of the house. Having a dead body in the living room was a difficult concept for a five-year-old to handle. Older sister Liz tried to fill the role as a surrogate mother, but it was a challenge.

Running the cottage fell to Sadie and her father Charles. Charles died in 1934, and Sadie was in charge for a long time. She passed operations on to Miriam Walker and her brother, Bennie Ashburn, who ran the cottage for a number of years. Life at Shearer was "like a big family. They all knew us,"[123] Doris recalled, referring to the family's prominence in the Highlands of Oak Bluffs.

"At one point, they [Miriam and Bennie] were thinking of selling it, and my mother and Aunt Liz said, 'You sell it over my dead body; we're not selling it.' So she and my Aunt Liz ran it," says Lee.

Doris met her husband, Herbert Jackson, at Shearer Cottage. As Lee tells the story, "He was seven years older than she. And he came down to Martha's Vineyard, to Shearer Cottage, selling magazines. He was about twenty and met my mother, who was thirteen. He told her that he would wait for her, and he did." Once again, Shearer proved the match maker. "And the funny thing is my mother grew up in Everett, which is right next to Malden, but they never knew each other until they came down here," Lee chuckled.

Lee shares another side of her mother: "She was an artist, and a lot of people don't know that. A lot of the art at Shearer was done by my mother. My mother didn't sell any. She never joined art exhibits. She was extremely talented." When she got married, Doris attended Suffolk Law School, but once she got pregnant, she withdrew. Lee says, "She was a top-notch student in law school." Doris regretted that she never graduated from law school. She did enroll in art classes at the Boston Museum of Fine Arts.

Doris's granddaughter Loren adds, "My grandmother was an artist. She took note of and marveled at the beauty in the world. In particular,

she always admired the beauty of nature—the ocean, trees, flowers, anything—and the physical beauty of people."

Herbert Jackson, Doris's husband, was a city councilor in Malden, which is a primarily white community. He was elected to two terms in the General Court and served as councilor at large. The city council chambers are named for him.

Lee recalls her parents with pride: "She was definitely the woman behind the man. My father was very handsome. Wonderful personality. Well loved by all. He was a Lion. He was district governor of the state and traveled all over. Between the city councilor and district governor of the Lions, she was always going out. He was a highly sought-after speaker. She always was right there with him, looking wonderful. She was always beautifully dressed. They were a team. She was every bit as glamorous, charming and highly thought of as he was. And people recognized that with her. He was very fortunate to have her. And she adored my father." Herbert L. Jackson passed away at the age of sixty-nine.

"We all knew each other," recalls Lee, referring to the popularity of the family. "I'm sure they all looked at my mom and Liz and knew we were Shearers. There weren't that many families here; there weren't that many African Americans here, when I was a kid, even when my kids were young. During my mom's generation, there were probably very few, so everybody knew each other and supported each other."

Lee mentions two people who advocated for Shearer Cottage, people who were not relatives but felt like part of the family. Olive Tomlinson's mother, Cutie, was a friend of Liz White, and that's why the Tomlinsons bought property on the Vineyard. Cutie's husband, Willie, was a photographer. "Uncle Willie was not just a photographer," says Lee. "He really captured a lot of what we did at Shearer." Lee adds, "He really did preserve a lot of the Shearer Cottage history. Uncle Willie was there. Processed his own film. It was really wonderful to have those pictures. You really appreciate it."

The other supporter was Dorothy West. She would chronicle Shearer events in her weekly column in the *Vineyard Gazette*. Year in and year out, stories about people who visited the cottage, fundraisers and activities such as Liz White's Summer Theater would reach a large audience through Dorothy's column.

Loren fondly recalls her grandmother, who lived across the street when she was growing up: "My grandmother, we called her "Didi," was an extraordinary woman. She was smart, physically fit, resourceful, business savvy, sophisticated, loving, glamorous, artistic, gorgeous, and she had a great sense of humor. She loved life and took great pleasure in all things—large and small. She would become very animated just walking outside into the fresh air. It didn't matter if the day was gray and brisk or warm and sunny. It was a joy to her to feel "alive." She viewed life as a blessing to be enjoyed and cherished."

Doris treasured and respected life: "Didi was a constant and extremely influential presence in our lives. In many ways, my brothers and I had two mothers. My mom, grandmother and I spent a lot of time together—shopping, going out to eat, 'girl' things—in my young adult years." Doris often took her grandchildren to special places, such as the Museum of Fine Arts, a play or musical performance or "a walk on the beach in Oak Bluffs after a hurricane while the ocean was still roiling." Loren adds, "Didi was a wonderful example of how to live a full, productive and meaningful life. I am truly fortunate to have had her as my grandmother."

Lee reflects on the generations: "My mother and her sister, me, my son, all met our spouses at Shearer. We all came here because of Charles Shearer." Lee is married to David Van Allen.

Each branch of the family is committed to the cottage. They want to preserve the property, treasure it, protect it. Lee says, "My kids have said they would do it. We always have the history and we have the big rock at Shearer Cottage right by it. It will always be Shearer Cottage."

Loren writes of her grandmother with pride: "She made us, her grandchildren, believe we were very special and that we could achieve anything we wanted to. She instilled family pride in who we are as African Americans and who/what we come from—particularly her husband's family history and the Shearer family history." Didi treated her grandchildren with respect: "She made sure we knew that we were as bright, strong and capable as anyone, no matter their color or history, that racism and society did not define us. She encouraged us to strive and not to settle for less than we deserved. She made us believe that nothing stood in our way of achieving our goals."

Lessons from her grandmother were far-reaching. Loren learned, from Didi, that "we might have a different path than others or we have different challenges, but we could do and be anything we wanted to." She taught that it was imperative to develop pride in yourself, "especially in a society that often saw us as second-class citizens or somehow inferior." Loren and the

other grandchildren grew up in the era of the civil rights movement while Didi came of age at a much earlier time.

———•———

Doris's sister was Elizabeth (Liz) White (1912–1994). The sisters' lives paralleled each other, both making major contributions to the heritage of Shearer Cottage. Deborah Toledo is the granddaughter of Elizabeth (Liz) Pope White: "I was very close to her. I grew up with her. She was almost as much a mother to me as my own mother." In the off-season, Deborah's parents lived near Liz in New York City, so she was "the babysitter of choice."

Each summer, Deborah stayed with Liz at her grand old house in the Highlands, Twin Cottage. Liz rented out half her house to a family with a child, so Deborah had a playmate. Liz threw many parties. "I remember sneaking down one of the two staircases to look around. Also, there was a hole in the floor and I could peek down into the kitchen."

"In the summer it was just the two of us. She was very involved with Shearer." Deborah continues, "Liz was close with Aunt Sadie [who ran Shearer]. We ate dinner at Shearer almost every night. I played while she was in the kitchen."

———•———

Liz White worked on Broadway as a theater dresser, assisting actors with wardrobe needs. She took the summer off to be on the Vineyard, to work at Shearer Cottage. "I hung out with my grandmother," says Deborah. "She treated me like a little adult." Deborah visited neighbors in the Highlands, like Dorothy West and Olive Bowles. "My grandmother would make plays with me, sing and do theatrical stuff. Every now and again, she took me to the beach."

"Theater was her life," says Deborah. She bought Twin Cottage in 1950, specifically "because she had always seen its possibility as a theater." Its wraparound porch made a dramatic stage. Liz White was not dark-skinned enough to play the role of an African American on Broadway, and the roles were stereotypical in any case. In response, she founded her own theater

group on the Vineyard, the Shearer Summer Theater, made up of friends and family with acting talent. Their first performance was in 1946, and the group flourished into the 1960s.

Over the years, Liz White produced nearly a dozen shows, from *The Women* to *Slabtown Convention* to *Angel Street*. *Cooling Waters* was a play she wrote and produced. Liz enticed friends and family, on vacation, to participate in the Shearer Summer Theatre, taking roles or working with the costumes, photography or publicity. Olive Tomlinson recalls drama on the Highlands: "Liz was so brave, so dauntless. Nothing stopped her."

Othello was the highlight of Liz White's theatrical career. She directed *Othello*, with an all-black cast and an emphasis on African heritage. Then an idea hit her: she would film the show. That became her focus from the early 1960s through the late 1970s. Eventually, the movie was released, at Howard University, in 1980. *Othello* is still shown, on occasion—the tribute to a dedicated professional.

As her granddaughter Deborah says, "She was an activist in a lot of respects. And yes, she made sure that there was a message of some sort that people could walk away with, that almost always had to do with the state of race relations."[124] Liz White believed strongly in the power of education and that the experience on the stage could resolve much of racism in society. She lived her beliefs.

Liz White died in 1994. Lee picks up the tale: "My mother needed a partner, so I helped my mother run Shearer Cottage and bought out several relatives. My mother was really the one who wanted to do it." She continues, "Maybe the last ten years my mother and I owned it completely. My mother and I always did very well. I'm very much like her. We never really clashed when we ran Shearer Cottage." Joint ownership of property can be a challenge, but in this case the family heritage trumps personal choice.

Shearer Cottage underwent major renovation during the tenure of Doris and Lee. Walls of the small bedrooms were broken down and large, comfortable suites created, with kitchen facilities and private baths. The dining room is now a family room. Lincoln Pope's tennis court became a side yard. Shearer Cottage no longer serves meals but still is a draw in the summer months.

The 100th anniversary of the founding of Shearer Cottage, in September 2012, was cause for a celebration. Lee spoke of her great-grandfather

Charles Shearer: "What he also did was bring up young graduates from Hampton who didn't have opportunities down south and got them jobs as waiters." In appreciation for his efforts, at the event "there was a letter from a group of those waiters. They called it the 'Owed to Shearer.' It was a letter of thanks to Charles Shearer for bringing them north. It was a poem."

In her later years, Doris had no shame or fear to do the work that needed to be done. In her eighties, she got out on the roof, and a relative was aghast that she would walk across a little roof, high in the air. "If it needed to be done, she'd do it. It kept her young. She'd wallpaper because my father didn't know how to hold a hammer. She'd decorate. She was special, a special lady," says Lee. She adds, "She was a very strong woman, a very bright woman. She was very supportive of her family, her children, grandchildren and great-grandchildren. She got to know my sons' children."

Even at ninety-six, Doris was agile and erect in her bearing. "A year before she died she was on her hands and knees scrubbing the shower floor," says Lee. Doris had no health issues, neither overweight nor with a weak heart. The end came when she suffered a fall and broke her ribs and then her hip, and that led to her demise.

Loren Van Allen adds a final thought:

Didi was always positive and optimistic. She taught her grandchildren to work hard and play hard, as she did. She worked very hard to keep Shearer Cottage open and viable over the years. She put her heart and soul into it. She also took time to relax and enjoy a day at the beach or a great meal. She taught us to save our pennies, to be financially responsible, to earn our keep and to contribute to the community we live in. She had integrity and loyalty and deep commitment to the people and things that were important to her. She was very giving and supportive of her family, but she never deprived herself of anything she wanted. She took time to take care of herself, to pamper herself. She believed in herself, in her own opinions, her own intelligence and her own ability to make things happen as she envisioned them.

Doris never felt inferior because of her race. "It's what you have to offer, what type of person you are. And that's the way I was brought up, and that's the way I have always lived."[125]

Doris always treasured and honored the beauty of the Highlands, her special niche in Oak Bluffs. While she lived off-season near Boston, she always considered the Vineyard to be her home. She raised her family to

Doris Pope Jackson with Senator Edward Brooke in 2007, at the home of Lynn and Dave Edmonds, Oak Bluffs. *Courtesy of Lee Van Allen.*

have that same respect for tradition. Her sister, Liz White, felt the same way about the tradition that was Shearer Cottage.

Gladys Widdiss was a Native American who treasured and honored the beauty of Gay Head. She, too, lived off-season near Boston for many years but always returned to the Vineyard; this was her home. As a teacher, craftsperson and tribal elder, she did everything she could to preserve, protect and promote her Native American heritage. Her family respects and honors her efforts.

Gladys Widdiss (1914–2012): Tribal Elder, Potter

Aquinnah

G ladys Widdiss lived her very full life for the Wampanoags of Martha's Vineyard. She epitomized the lifestyle, culture and heritage of her tribe. More than anyone, she instigated tribal recognition by the federal government, key to tribal security and stability.

Born in the Thomas Manning Homestead in Gay Head (now Aquinnah) during the First World War, Gladys treasured her youth in the small-town community made up of fellow Native Americans. She never knew her father, William Malonson, who worked on the construction of State Road in the early years of the twentieth century. However, she never felt deprived. "Having a father wasn't something that we missed. Being a Native American and being up here, we had family…there were always uncles around and cousins and other relatives, so they picked up the slack. It was just a way of life here and this was the way we lived. The door to our house was never closed. Someone was in and out all the time."[126] Her mother, Minnie Manning, and extended family more than made up for her absent father.

Gladys recalled playing ball in a field where the town offices now stand. She would find a stone and wrap rags around it for the bag or base. Children invent their own games. She loved to swim down in Lobsterville and attended school in the little red one-room schoolhouse (now the library) with a dozen or so other students. She recalled they had to haul water to the school from a spring behind the present town hall. In high school, she journeyed down Island and graduated from Tisbury High School in the class of 1932.

"The Cliffs, of course, were our favorite place," she recalled fondly. "That was our main playground."[127] A popular winter pastime was sledding on Lighthouse Road. "We did practically everything together. Age didn't make any difference. Whenever we had anything up here like a party, Christmas and all that stuff, everybody came."[128]

As a child, Gladys learned to live off the land. She nibbled watercress and fiddlehead ferns, which she called pull-ups. Boxberries (wintergreen) were like candy. To pick strawberries, she and her friends would head to the Down East Pasture. Cranberries ripened in early autumn. Her mother boiled sassafras to make tea and showed Gladys how to make candles from bayberries. (Candles were essential, as there was no electricity in Gay Head until the early 1950s.) To make bayberry candles, you had to boil the berries until the wax floated to the top, stick in a string and there's the candle. Because it could take several hours for a doctor to come from down-island, the tribe medicated and cared for their people themselves. A common remedy for a cold was to drape cooked skunk cabbage on your chest: both the smell and the oil would revive you.

Gladys saw her first automobile in 1920, when she was six years old. With friends, she piled into a neighbor's car, Maurice Belain's, and drove "over south."

She and her mother lived with two cousins and an aunt at the Homestead, along with her grandparents. Gladys's great-grandparents spoke Wampanaak yet never passed it on to subsequent generations. Everyone was expected to speak English.

One recollection Gladys would often recall was of her grandfather rising early to start the day. He would open the windows and sing or chant, which was a Native American custom. "When she was growing up," son Carl's partner, Pam, recounted, Gladys "recalled the traditions of singing, drumming and dancing. She used to wake up in the morning in the Homestead. And she lived there with her mother and grandfather. Her grandfather would be singing in the morning, every morning." Carl Widdiss adds, "He sang in the morning to greet the spirits. Every morning. She couldn't understand the words because they were sung in Wampanaak. You greet that day. That's what you do every morning, you greet the day."

Gladys's grandfather kept oxen. "When I was a youngster, oxen was [sic] everything. About everyone had a pair of oxen."[129] Her mother, Minnie, trained the oxen down on the beach so they would get familiar with her voice. The oxen were put to work to plow the fields, which were then seeded by hand. The family raised corn, beans, turnips, potatoes, tomatoes and lettuce. Vegetables were stored in the basement of the Homestead. Hay was mowed, then raked into

Picture postcard of Gladys Widdiss, with her clay bowls, on the beach in Gay Head. *Courtesy of Carl Widdiss.*

piles, allowed to dry thoroughly, tossed up and onto the oxcart and then hauled to the barn. Gladys recalled they had a cow and chickens as well. She said you could get clams all year long. Because there was no pump at the Homestead, family members had to haul water from the spring.

Bettina Washington shares an impish memory Gladys told of her youth. When she was with her cousin Hazel, Gladys and she would "go get the milk; it's so nice and cold, and sometimes they'd drink all the milk, then drop the bottle on a rock and say it broke." Another tale Gladys liked to tell teased Mr. Vanderhoop. A group of kids would go up to the Vanderhoop house at night and ask, "Can Helen come out to play?" And Mr. Vanderhoop would come to the door and say, "No, Helen's in bed." Then the kids all shouted, "Oh no she's not!"

Gladys met her husband at her cousin Hazel's house outside of Boston. She moved to Wayland and lived there. During World War II, she painted airplane dials with radium. Every summer, she returned to the Vineyard

with her four children: Dawn, Donald, Carl and Mark. While they attended school in Wayland, summer vacation and holidays would find them back on Gay Head. It was always their home. Carl says, "We always came back here; we always commuted; every school vacation, always considered this home. Summers as a child."

A strong strain of Native American culture ran through the life of Gladys Widdiss. An important concept revolved around the land, use of the land and the value of the land. Gladys was a potter. Her son Carl fondly recalled her skill. All her bowls were pinched by hand; she never used a wheel. The work was

Gladys, in regalia, holding her sun-dried clay bowls. *Courtesy of Carl Widdiss.*

sun-dried; she never used a kiln. Gladys often said, "The clay tells you what to do." She worked with the natural resources in her environment, crafting work she had learned from her mother and grandparents. She kept tradition alive.

Carl's partner Pam recalls finding clay to make bowls. "One day, I remember Gladys had run out of clay. You and your brothers were all out at the cliffs with a wheelbarrow or a wagon. There was Carl, Mark and Don, with a wheelbarrow. You were so used to doing it. She was walking along saying what color she wanted. And your mother was telling you what to do, what clay to pick up. She was always directing."

Carl respects that heritage. "She gifted this bowl to me," he says, gently holding one of her decorative creations. "It's all pinched. Traditional round bowl." Gladys was renowned for her work. "She won a number of blue ribbons at the Agricultural Fair," he says with pride. (Carl also won a blue ribbon for a pinched clay bowl he made in her honor.)

Gladys sold her pots at the cliffs. "Everyone had an informal set-up, a table, either at the cliffs or at town hall," Carl explains. "She always had a table. As far back as I remember, a lot of people just had a table, or a fold-up table." He holds a photo of his grandmother. "That's kind of a good example of what the tables looked like, with Minnie Manning. Inventory on the table and more underneath."

Bettina Washington adds, "All the pottery was molded, no wheel and not kiln dried. There's a pattern. You can tell who made it. It was pretty interesting." She has a clear memory as a child bouncing around and being admonished to "stay away from those pots!"

Gladys made jewelry as well. "I have the earrings she made my mother," adds Bettina. "They have daisies with loops. There's a way they were all put together, like collars but didn't join, just looped over, and there would be daisies incorporated in the side, petals come out on the side. They did loom work, on a bead loom, for a head-band."

She adds, "And she wanted the shop, and we got the shop going. We finally got it going." Her shop at the cliffs provided a permanent place for her wares. Son Donald now works and sells wampum there. Tradition continues through the generations.

One memorable day, Bettina recalled that she and Gladys were working behind the counter of the shop. Two women came in. "One woman said, 'So, the whole island has Indians on it.' I said, 'The whole country had Indians on it.' She asked, 'Well, how did you get here?' I said, 'Oh, we canoed over.' Gladys was standing there and didn't look at the woman; she looked at me and said, 'We walked!' I will always believe she was the teacher."

The goal of the shop was to sell native crafts to tourists. While Gladys was quoted as saying she didn't like the tour buses lingering at the cliffs, she did appreciate selling her decorative bowls. "You have to look at things both ways," says Carl. Over the years, Gladys made and sold beadwork, rings, beads and headbands at the cliffs, as well as her pottery.

Another aspect of her pottery work was that she shared her craft. Not only would she give presentations for Native Americans, but also she often presented pottery demonstrations at the Boston Children's Museum. Carl holds a photo, dated 1991. "She's giving a pottery demonstration, which she did regularly at the Children's Museum." She explained how she made the clay pots, as well as clay beads. At times she wed the pottery with jewelry, making necklaces or bracelets, with beads made of clay. "They don't break, unless you really impact them," says Carl.

Gladys always enjoyed sharing her experiences. *Courtesy of Carl Widdiss.*

Bettina recalls, "When they started doing Indian Day at the Children's Museum, she would sell the pottery. For the most part someone searched her out. There are two or three people who have serious collections of her pottery. One woman, every year, would buy some of her pottery." Gladys also gave demonstrations at local schools.

The most lasting impact Gladys Widdiss had on her world was her involvement in Indian affairs. She recalled her first activity, in the 1950s. Prior to that, "we were just Gay Headers, that's all we were." The move for the rights for the Wampanoags came in the early 1960s. Carl speaks of his mother: "Her inspiration, her whole life, was how it was important for her to motivate people to know about Indian people, not just Native Americans but all people. To remember who they are."

Bettina recalls the genesis of early efforts at tribal recognition. Gladys took her on a trip to the Cape. "Usually we were going to some Indian event, something was going on. That's what I did, I'd stay with her." She adds, "I remember when I was little, going over to Mashpee for a powwow and knowing the people over there. She was always in the middle of it." Carl, too, recalls attending the Federated Eastern Indian League in Mashpee where elders studied the foundation of the tribe. There was a lot of discussion about what the Native Americans were doing, and from these discussions, Carl says, "the Elders held meetings that blossomed into the formation of what became the foundation for tribal recognition."

Gladys contacted the Native American Rights Fund (NARF) to work for Indian land and rights. She worked from home, while her brother Donald Malonson

was in Gay Head. He was Chief Running Deer; Gladys was Wild Cranberry. Together, and with others, they initiated the effort to establish rights for the Gay Head Indians. She was instrumental in the formation of the Wampanoag Massachusetts Corporation. "I never had any idea I was going to be president of the corporation for eight years...I had no idea of ever being caught up in politics. I hate politics to this day. Always did. But I ended up learning."[130]

In an interview conducted by Linsey Lee in 2004, Gladys describes the effort: "We did the tribal lands lawsuit first, and then we decided to try for federal recognition. The land suit passed. We had more trouble with some of our own people than we did outsiders." Federal recognition followed the land lawsuit. "They based it on whether or not you had been in control of your tribe since historical times. And we could trace it back. That's the one thing we had going for us, that we'd never been anywhere else. This tribe has stayed here; we'd been on this island from time immemorial." She went on, "As I say now, looking back at it all, evaluating it, they [the Wampanoags] gave them [the government] too much and didn't ask anything in return."[131]

Federal recognition was granted in 1987. The tribe had many people who worked for a common goal, yet Gladys was key. "She was," says Carl, "but there were a lot of pivotal people that worked on every aspect of the tribe's regeneration. I don't think there was any one person; it was a group effort. She was the key cog. Everyone played a part." Her inspiration motivated Indian people to remember who they were and allowed them to be who they are.

Bettina appreciates the effort for federal recognition: "My son, who was born in 1990, only knows himself as a member of a federally recognized tribe. That's who we are. It's been an involvement into a more formalized relationship with government. It's not that we're any more a tribe than we were before. It's that relationship with government. She [Gladys] was very instrumental. She was the chair of the tribe at the time, bringing us to that point." Bettina continues, "Now that we're a federally recognized tribe, we have a responsibility to work for the betterment of the tribe." When Carl sought to have the town change its name from Gay Head to Aquinnah, he says, "She always considered it had been Aquinnah all along. She worked for Native Americans her whole life."

It always comes back to the land, the bounty and the beauty of Gay Head. Carl's partner Pam recalls, "There was a time, in the last few years, when

Gladys Widdiss at the wheel of son Carl's 1929 Model A Ford, with a rumble seat. *Courtesy of Carl Widdiss.*

she was still driving. She took her car down to the cranberry bogs. We came down later, and we were not able to find Gladys. She had a secret spot where she picked cranberries. Turns out she was with her great-grandson, only about four or five. She wanted to pick cranberries at her secret place."

Pam continues, reflecting on Gladys long life: "She had a rake. And she picked tons of cranberries. She told stories about Cranberry Day, the Tuesday after Columbus Day. She made the absolute best cranberry juice." Gladys knew which plants produced the best fruit: first rose hips, then grapes, then beach plum and finally cranberries. She made a delightful rose hip syrup, beach plum pie and jelly. Pam adds, "I feel like Gladys is still right here."

Gladys and Pam served as judges for the Boston Area Roadsters when they made their annual Power Cruise to the circle in Aquinnah.

Bettina reflected that Gladys always wanted to be a teacher but could not afford to go to school. In many ways, she reached more people as a teacher of Native American culture and tradition. "She was able to reach out on all different levels and in a lot of different places, not just a classroom. She was a spokesperson." Many of her generation have passed on; she was among the last.

The annual appeal of the Aquinnah Cultural Center (ACC) recognizes Gladys: "We honor the life of Mrs. Gladys Widdiss, tribal leader, a respected elder, gifted Gay Head potter and former Vice-president of our board of directors. We were all honored to serve alongside her, and we feel that it is only appropriate that we honor her work and support, which was an important part of how ACC came to be." The image of one of her decorative bowls adorns its bookmark.

As Carl Widdiss recalls his mother, from her work as a potter to the efforts for tribal recognition: "I remember her as a messenger, a teacher of culture to schools with regular presentations. I don't know how she did it all, from cub scouts, girl scouts, PTA, Boosters; she did so much. Were there more hours in the day back then?"

.

Epilogue

Fifteen women. Virtually all lived in the twentieth century. Each made an individual and indelible contribution to the community of Martha's Vineyard. Whether summer people or year-rounders, each considered the Vineyard her home. They wanted the best for their place of residence.

Regarding their residence, four of the women lived in West Tisbury, three each in Vineyard Haven and Oak Bluffs and two each in Aquinnah, Edgartown and Chilmark (Adams sisters).

The predominant career of these women was on the stage: Katharine Cornell, Patricia Neal, the Adams sisters and Lillian Hellman (playwright). Helen Lamb was trained in theater; Nancy Luce certainly exhibited theatrical attributes. Two served as correspondents for the *Vineyard Gazette* (Dorothy West and Dionis Riggs) as a sidelight to myriad writing efforts. One set standards for manners, while each of the others carved a niche in an individual career: as a horticulturist, a librarian, a stenographer, a teacher, a camp director, an artisan and an innkeeper.

These women lived long and healthy lives. Their average age was ninety, and seven of the fifteen lived well into their nineties (Dionis Riggs, Gladys Widdiss, Doris Jackson, Betty Alley, Helen Lamb, Lucy Adams and Dorothy West); one even turned one hundred (Polly Hill). Three died in their seventies: Sarah Adams (seventy-five), Nancy Luce (seventy-six) and Lillian Hellman (seventy-nine).

On a personal note, I invited Patricia Neal to chair our annual Alzheimer's Walk one year and had the honor of driving her. I drove the bus with Helen

Lamb for a Camp Jabberwocky event. On a tour of campground cottages, we visited the house of Lucy Adams, with its lowered kitchen counter. I spoke with Gladys Widdiss when I worked on the book about the Wampanoags, and I met Doris Jackson when I brought visitors to Shearer Cottage. At the Arboretum, I saw Polly Hill on her golf cart. My wife, Joyce, knew Dorothy West through her town column. Joyce taught with Helen Manning in Oak Bluffs and interviewed her for an educational project. Betty Alley waved when we drove by her house on Vineyard Avenue. As a tour bus driver, I knew the stories of passing the Emily Post garden, although buses no longer take that route. I read about the bravery of Nancy Whiting, and I was in a writing group with Dionis Riggs's daughter Cynthia at the Cleaveland House. On tour, I point out the cemetery where Lillian Hellman is buried, and I've been to many events at the Katharine Cornell Theatre in Vineyard Haven. Daily, I drive my school bus by the chicken statuettes at the gravestone of Nancy Luce.

Each of these women made a mark on my life, as well as a contribution to the Vineyard. Each added something special to the fabric of the community and treasured the rural quality of the island. These women weathered challenges and tragedies in their personal lives, from death of children, to divorce, to disease. Yet each one persisted and survived to make her mark. They did their part to improve their town, serving on committees, raising the level of intellectual appreciation with their contributions to theater and the arts and, in the end, improving the overall image of Martha's Vineyard. They brought us to a higher level.

We acknowledge their commitment to community, their contributions to society and their lasting impact on Vineyard history and culture.

Notes

FOREWORD
1. Styron, *By Vineyard Light*, 91.

CHAPTER 1
2. *Vineyard Gazette*, April 21, 1989.
3. Ibid., June 20, 1952.
4. Ibid.
5. Ibid., July 23, 1982.
6. Ibid., July 8, 1870.
7. Barrow, *Edible Vineyard*, summer 2012.
8. *Vineyard Gazette*, August 17, 1984.
9. Ibid., December 30, 1920.

CHAPTER 2
10. Peter Benjamin, e-mail, September 28, 2012.
11. *Vineyard Gazette*, July 28, 1921.
12. Ibid., February 20, 1880.
13. *Detroit Free Press*, July 28, 1891.
14. *Vineyard Gazette*, August 11, 1921.
15. *New York Sun*, September 28, 1929.
16. *Vineyard Gazette*, August 11, 1921.
17. *Boston Sunday Herald*, November 25, 1923.
18. *New Bedford Times*, February 12, 1931.

CHAPTER 3
19. *New York Times*, September 27, 1960.
20. Ibid.
21. Didion, *The Year of Magical Thinking*, 61.
22. Claridge, *Daughter of the Gilded Age*, 281.
23. Ibid., 282.
24. Ibid., 315.
25. Catling, Susan, *Martha's Vineyard Magazine*, March 2010.

26. Claridge, *Daughter of the Gilded Age*, 415.
27. Ibid., 350.
28. Ibid., 371.
29. Ibid., 301
30. Ibid., 371.
31. Ibid.
32. Ibid., 340.
33. Ibid., 425.
34. *New York Times*, September 27, 1960.

CHAPTER 4
35. *New Bedford Standard Times*, June 11, 1974.
36. Mosel and Macy, *Leading Lady*, 413.
37. *Harper's Bazaar*, September 1942.
38. *Vineyard Gazette*, April 20, 1951.
39. Mosel and Macy, *Leading Lady*, 418.
40. Ibid., 515.
41. Ibid., 516.
42. *New York Times*, June 10, 1974.

CHAPTER 5
43. Lee, *More Vineyard Voices*, 186.
44. Wright, *Lillian Hellman*, 288.
45. Lee, *More Vineyard Voices*, 195.
46. Ibid., 270.
47. Wright, *Lillian Hellman*, 369.
48. Mosel and Macy, *Leading Lady*, 373.
49. Ibid., 419.
50. *Vineyard Gazette*, July 3, 1984.
51. Ibid., July 6, 1984.
52. *New York Times*, November 3, 1996.

CHAPTER 6
53. *Baltimore Sun*, May 12, 1997.
54. *New York Times*, May 12, 1997.
55. Lee, *Vineyard Voices*, 116.
56. *New York Times*, May 12, 1997.
57. Lee, *Vineyard Voices*, 118.
58. *New York Times*, May 12, 1997.
59. Ibid.
60. Lee, *Vineyard Voices*, 118.
61. Riggs, *Collected Poems*, 44, 45.

CHAPTER 7
62. Lee, *Vineyard Voices*, 34.
63. West, *The Richer, The Poorer*, 1.
64. Lee, *Vineyard Voices*, 35.
65. Ibid.
66. West, *The Richer, The Poorer*, 3.

67. Lee, *Vineyard Voices*, 36.
68. West, *The Richer, The Poorer*, 3.
69. Ibid., 6.
70. Saunders and Shackleford, *Dorothy West Martha's Vineyard*, 6.
71. Lee, *Vineyard Voices*, 36.
72. Saunders and Shackelford, *Dorothy West*, 150.
73. Lee, *Vineyard Voices*, 34.

Chapter 8

74. *Vineyard Gazette*, July 3, 1998.
75. Graves, *Leaves from a Life*, 4.
76. Lee, *Vineyard Voices*, 152.
77. Graves, *Leaves from a Life*, 1.
78. Ibid., 13.
79. *New York Times*, April 30, 2007.
80. Lee, *Vineyard Voices*, 152.
81. *New York Times*, April 30, 2007.

Chapter 9

82. Lee, *Vineyard Voices*, 55.
83. Ibid.
84. Ibid., 56.
85. Ibid., 55.
86. Ibid., 57.
87. *Vineyard Gazette*, November 22, 2007.

Chapter 10

88. Joyce Dresser interview, 2000.
89. Ibid.
90. Lee, *Vineyard Voices*, 211.
91. Ibid.
92. *Vineyard Gazette*, July 28, 1995.
93. Lee, *Vineyard Voices*, 212.
94. Joyce Dresser interview, 2000.
95. Ibid.

Chapter 11

96. Lee, *Vineyard Voices*, 8.
97. Ibid.
98. Ibid., 9.
99. Ibid.
100. Ibid., 10.
101. *Our Portuguese Heritage*, June 25, 2005.

Chapter 12

102. Neal, *Autobiography*, 480.
103. Shearer, *An Unquiet Life*, 324.
104. Ibid., 490.
105. Ibid., 331.

106. *Martha's Vineyard Times*, July 27, 2011.
107. *Vineyard Gazette*, August 9, 2010.
108. Ibid., August 10, 2010.
109. *Martha's Vineyard Times*, July, 27, 2011.

CHAPTER 13
110. Lee, *More Vineyard Voices*, 116.
111. Ibid.
112. Ibid.
113. Ibid.
114. Ibid., 118.
115. Ibid.

CHAPTER 14
116. Lee Van Allen, daughter of Doris Jackson.
117. Ibid.
118. Lee, *More Vineyard Voices*, 134.
119. Ibid., 131.
120. Ibid., 130.
121. Ibid., 131
122. Ibid.
123. Ibid., 133
124. *Martha's Vineyard Arts & Ideas*, mid-summer 2012.
125. Lee, *More Vineyard Voices*, 133.

CHAPTER 15
126. Lee, *More Vineyard Voices*, 32.
127. Ibid.
128. Ibid., 33.
129. Ibid., 34.
130. Ibid., 36.
131. Ibid.

Bibliography

Carrick, Carol. *Two Very Little Sisters.* Boston: Clarion Books, 1993.

Claridge, Laura. *Daughter of the Gilded Age, Mistress of American Manners: Emily Post.* New York: Random House, 2008.

Didion, Joan. *The Year of Magical Thinking.* New York: Knopf, 2005.

Graves, Ralph, *Leaves from a Life.* West Tisbury, MA: Polly Hill Arboretum, 2003.

Lee, Linsey. *More Vineyard Voices.* Edgartown, MA: Martha's Vineyard Historical Society, 2005.

———. *Vineyard Voices.* Edgartown, MA: Martha's Vineyard Historical Society, 1998.

Manning, Helen, with JoAnn Eccher. *Moshup's Footsteps.* Aquinnah, MA: Blue Cloud Across the Moon Publishing Company, 2001.

Mosel, Tad, and Gertrude Macy. *Leading Lady: The World and Theatre of Katharine Cornell.* New York: Little, Brown & Co., 1978.

Neal, Patricia, with Richard DeNeut. *As I Am: An Autobiography.* Boston: G.K. Hall & Co., 1989.

Riggs, Dionis Coffin. *The Collected Poems of Dionis Coffin Riggs, with block print images by Sidney Noyes Riggs.* Tisbury, MA: Tisbury Printer, Cleaveland House Books, 1998.

Riggs, Dionis, with Sidney Noyes Riggs. *From Off Island.* New York: McGraw Hill, 1940.

Saunders, James, and Renae Shackelford. *The Dorothy West Martha's Vineyard (Stories, Essays and Reminiscences by Dorothy West Writing in the* Vineyard Gazette*).* Jefferson, NC: McFarland & Co., 2001.

Shearer, Stephen. *Patricia Neal: An Unquiet Life.* Lexington: University Press of Kentucky, 2006.

Stoddard, Doris. "The Little Ladies from Chilmark." *Intelligencer,* August 1979.

Styron, Rose. *By Vineyard Light.* New York: Rizzoli International Publications, 1995.

Teller, Walter. *Consider Poor I.* Dukes County Historical Society, 1984.

West, Dorothy. *The Richer, The Poorer: Stories, Sketches and Reminiscences.* New York: Doubleday, 1995.

Wright, William. *Lillian Hellman: The Image, The Woman.* New York: Simon and Schuster, 1986.

BIBLIOGRAPHY

ADDITIONAL RESOURCES

Barrow, Samantha. *Edible Vineyard* (Summer 2012).

Emily Post Institute
444 South Union Street
Burlington, VT 05401

The Patricia Neal Rehabilitation Center
1901 Clinch Avenue
Knoxville, TN 37916

This Is Our Island. Documentary created for 300th anniversary of Tisbury.

Thomas, Marianne Holmes. Our Portuguese Heritage, 1860–1900. history.vineyard. net/mvpgp/Medeiros. [An informal genealogy of three thousand families on Martha's Vineyard]

About the Author

Thomas Bender Dresser has a business card that reads: writer/bus driver.

After a stint teaching elementary school and a couple of decades as a nursing home administrator, Tom finally started to write.

Women of Martha's Vineyard is his fifth book with The History Press. One fan raved, "Mr. Dresser, you've created quite a niche for yourself."

Visit thomasdresser.com for more information.

Tom first met Joyce in the autumn of 1959, when they entered junior high. Fast-forward to 1995, when they re-met at their thirtieth high school reunion.

Tom and Joyce have been married for fifteen years, and enjoy five children and seven grandchildren. How fortunate can two people be!

ALSO BY THOMAS DRESSER

Dogtown: A Village Lost in Time (1995)
Beyond Bar Harbor (1996)
It Happened in Haverhill (1996)
Looking at Lawrence (1997)
Tommy's Tour of the Vineyard (2005)
Mystery on the Vineyard (2008)
In My Life (2009)
It Was 40 Years Ago Today (2009)
African Americans of Martha's Vineyard (2010)
The Wampanoag Tribe of Martha's Vineyard (2011)
Disaster Off Martha's Vineyard (2012)